BASICS
FILM-MAKING

02

Screenwriting

Robert Edgar-Hunt
John Marland
James Richards

ava | Academia
the environment of learning

An AVA Book
Published by AVA Publishing SA
Rue des Fontenailles 16
Case Postale
1000 Lausanne 6
Switzerland
Tel: +41 786 005 109
Email: enquiries@avabooks.ch

Distributed by Thames & Hudson
(ex-North America)
181a High Holborn
London WC1V 7QX
United Kingdom
Tel: +44 20 7845 5000
Fax: +44 20 7845 5055
Email: sales@thameshudson.co.uk
www.thamesandhudson.com

Distributed in the USA & Canada by:
Ingram Publisher Services Inc.
1 Ingram Blvd.
La Vergne, TN 37086
USA
Tel: +1 866 400 5351
Fax: +1 800 838 1149
E: customer.service@ingrampublisherservices.com
www.ingrampublisherservices.com

English Language Support Office
AVA Publishing (UK) Ltd.
Tel: +44 1903 204 455
Email: enquiries@avabooks.ch

ISBN 2-940373-89-2 and 978-2-940373-89-5

10 9 8 7 6 5 4 3 2 1

Design by Darren Lever

Production by
AVA Book Production Pte. Ltd., Singapore
Tel: +65 6334 8173
Fax: +65 6259 9830
Email: production@avabooks.com.sg

All reasonable attempts have been made to trace,
clear and credit the copyright holders of the images
reproduced in this book. However, if any credits
have been inadvertently omitted, the publisher
will endeavour to incorporate amendments in
future editions.

A Chump at Oxford
(dir: Alfred J. Goulding 1940)

Screenwriters who are enrolled on film production courses sometimes complain about theory courses, believing that they are irrelevant to the craft that they wish to learn. This is to be mistaken.

Table of contents

This book aims to provide you with a detailed introduction to the art and craft of screenwriting. Unlike many texts on screenwriting, this book can be read in two distinct ways. Read through *Basics Film-Making: Screenwriting* from beginning to end in sequence, and discover the process by which a screenwriter develops their script from initial idea through to producing their final manuscript; or dip into it at leisure as you write and develop your own script, and find guidance on the many stages involved in realising your own ideas.

There are many practical pointers running throughout the book to help you think creatively, get to grips with your script and to guide you through the tricky bits, in the form of exercises, techniques and tips from industry professionals. We have devised these to both help improve your writing skills and to crucially boost your powers of persuasion.

A **running glossary** explains key terms clearly and precisely

Glossary

Character biography: a device often used by writers to outline the back story of a character. Sometimes used by directors when working with actors.

Action is character

Though we can learn a lot about a person through listening to what they say and how they say it, it is the way in which a person behaves that reveals their true nature – in movies and in reality. Someone may boast about their strength and courage, but if they run away when danger threatens, this is usually a fair indication that they are ultimately a coward.

Why do characters behave like that?

Or, alternatively, what made them the way they are? This is sometimes called the **character's back story or biography.** Many factors go into building a character – real or fictional. What were their parents like? Were they rich or poor? How many siblings do they have? Where did they go to school? What did they want to be when they were a child? Who was their first true love?

The more questions like this that you can ask – and answer – the better you will know your character and the more real they will be. For major characters, you need to write a fairly comprehensive biography. This takes time and thought, but once you have done it you will be able to answer the question: who are they?

Names

Names matter – they can be used to tell us things about the character. In the martial arts classic *The Way of the Dragon* (1972), Chuck Norris's character is called Colt, making us think both of the young male horse and of the gun – both symbols of American masculinity.

It can be a bad idea to spend too much time on finding appropriate names for characters. They can always be christened with a provisional or temporary name and renamed later.

Character biography

If you're stuck with a character biography and your character has a job, try writing the CV that got the character the job. Or try writing their annual appraisal report. Think how they would react if they were real people.

Let's face it. If, as an audience, we didn't believe that the characters on screen were in some way real, the whole act of watching a film would be pointless.

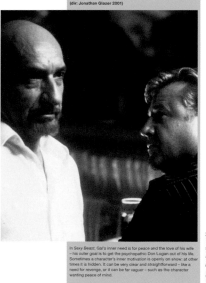

Sexy Beast
(dir: Jonathan Glazer 2001)

In *Sexy Beast*, Gal's inner need is for peace and the love of his wife – his outer goal is to get the psychopathic Don Logan out of his life. Sometimes a character's inner motivation is openly on show: at other times it is hidden. It can be very clear and straightforward – like a need for revenge, or it can be far vaguer – such as the character wanting peace of mind.

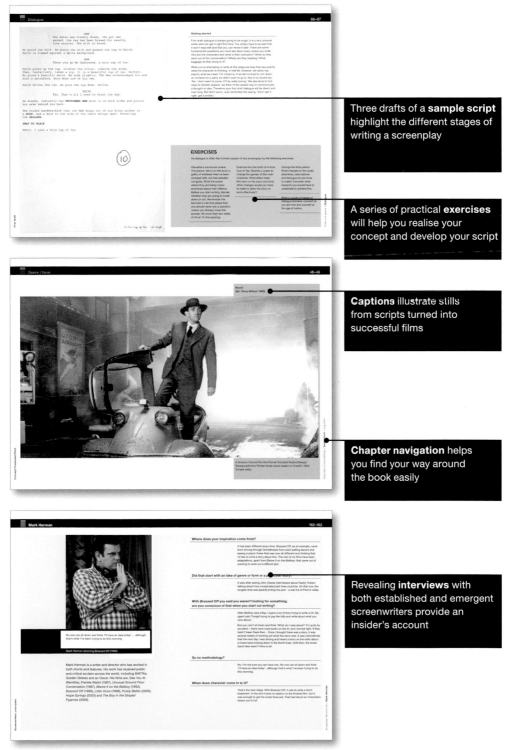

Dialogue — 86–87

Three drafts of a **sample script** highlight the different stages of writing a screenplay

A series of practical **exercises** will help you realise your concept and develop your script

Genre / form — 48–49

Captions illustrate stills from scripts turned into successful films

Chapter navigation helps you find your way around the book easily

Mark Herman — 162–163

Revealing **interviews** with both established and emergent screenwriters provide an insider's account

How to get the most out of this book

People rarely like being told they are beginners, but we all have to start somewhere. As with any book that aims to guide you through the process, there is always the temptation to ignore the early sections – writers are often the worst offenders.

Problems with screenplays are often the result of writers ignoring first principles. Be aware of the process and make sure that you know the rules before you break them. Recognising your own practice is crucial; otherwise you may find yourself building up a catalogue of errors and glitches that will cause problems later.

As you develop and learn, self criticism will become automatic; you will know what not to write, what mistakes to avoid.

The screenplay is at the heart of film-making. Without it a film cannot be made. It tells actors what to say, it tells a set designer what to build, it tells a sound recordist what to record and it provides the director with a guide to what shots they will need to use.

A good screenplay is the master plan for a project that will give many people a lot of pleasure. To design one requires considerable thought and dedication.

This book cannot guarantee you success. It cannot list shortcuts or magic formulas, because there are none. It cannot write your script for you nor comment on it once it is finished. What it can do, however, is explain some of the rules and conventions of screenwriting, take you step by step through the process and provide you with the confidence and knowledge to write and – crucially – rewrite your own screenplay.

Why short film?

Nearly all screenwriters aspire to write a feature film. This is an understandable and ultimately attainable ambition.

The British film industry produces about a hundred films a year. Most film companies receive at least a thousand scripts a year; some many more. Even a low-budget feature film can cost over a million pounds and making a feature is a major operation that normally involves hundreds of people.

For those wanting to get started in film-making, the short film has some key advantages over the feature. It takes far less time to write, can be more experimental and is much easier to make. The power of digital technology means you can even shoot and edit it yourself.

The Internet allows you the opportunity to show your short film to a worldwide audience. There are also a growing number of short film festivals held around the world.

Studio One, York St. John University, c.1963

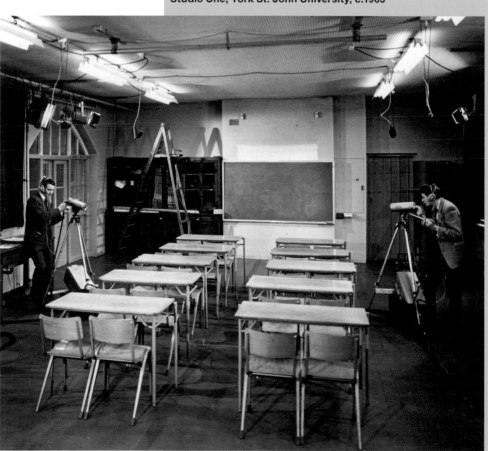

Without a script, you would have an empty room and a couple of
geezers with all the technology in the world – but nothing to film.

Short films can also pack a tremendous punch. We will often remember a good short film more vividly than a feature. They can achieve an intensity that is hard to sustain in a feature film.

Short films are also good for getting writers and directors noticed. Film-makers such as David Lynch, Mark Herman, Shane Meadows and David Yates first made their mark with short films. Many others cut their teeth on adverts – which are shorts after all – directors such as Ridley and Tony Scott.

The short film writer as a student

When asked whether she felt that university writing courses stifled creative talents, fiction writer Flannery O'Connor replied: 'Not enough of them'. O'Connor's humorous comment highlights the importance of education when applied to the dramatic writer – education both formal and informal.

A screenplay is one of the most highly structured forms of writing any writer can undertake. To start writing without knowing how film structure works is like trying to build a house without architectural blueprints. You may get quite a long way by simply piling bricks on top of each other, but you are very unlikely to complete the house. At some point it will simply collapse under its own weight! So will an unplanned script.

Theory is not confined just to structure; an understanding of semiotics, *mise en scène*, genre and iconography helps the writer to enrich their screenplay. These are not simply academic concepts – they act as a guide and a checklist. A screenwriter must use all the tools at their disposal to convey meaning – to tell a story.

It's also the case that theory and practice cross-fertilise each other. Theoretical concepts become easier to understand when they are applied to an actual screenplay. Very often, writers discover that they already know the concept – but not the name of it. Theory is vital: the writer who ignores it will rarely, if ever, succeed.

Finally

Screenwriting is hard work. If you can write five pages of your screenplay in a day, you are doing well. The job can sometimes be frustrating, exhausting and demoralising. This book is designed to help you make it fascinating, fulfilling and exciting. Good luck!

Chapter by chapter

What is a screenplay?

This chapter sets out the fundamental nature of a script and the role of the screenwriter. In examining these essentials, it also looks at the tricky concept of inspiration. Working out where ideas come from can be the hardest moment in starting your career as a writer. Telling you how to 'do it' is impossible and thus guidelines and basic principles are established here.

Concept/treatment/pitch

Developing your idea into a concept worthy of development is the next stage in the process. This chapter explores the idea of the screenwriter as student of their own medium. Key theories of narrative are established and discussed. The established process of moving from log line to pitch, through treatment to step treatment is clearly outlined and made simple.

First draft

First draft examines the basis of the script format and the detail of communicating ideas. With specific reference to character, the fundamentals of meaning and action are explored as key to the establishment of plot. *A Nice Cup of Tea* is an original script, presented as a case study to help you apply what you learn.

Second draft

This chapter is about refinement, whether you are working on two drafts or more. This allows for a more detailed discussion of the thorny subject of dialogue – normally the most difficult thing of all, no matter how experienced the screenwriter. The script established in the preceding chapter is developed and amended.

Script editing

The role of the script editor is one of the most undervalued in cinema. This chapter establishes the importance of this role as well as looking at how a script editor develops a critique that is of use to the screenwriter. This is to allow the development of the screenwriter who is also their own best script editor.

Screenwriters: unscripted

These interviews with both new and established writers demonstrate the commonalities and the differences in writing practice. Screenwriting is a solitary activity. You won't gain direct advice on your script by reading this chapter, but you will get reassurance that you are in good company when you differ from the practice laid down as law in every other book.

WHAT IS A SCREENPLAY?

Screenwriting is hard work.

We all love the movies, and plenty of people say they have a great idea for a movie of their own. However, a screenwriter is more than a film buff with a pen.

Writers are supposed to avoid clichés, but here is one you simply can't afford to ignore: writing is 1% inspiration, 99% perspiration. Thomas Edison said something very close to this in 1903 when talking about his scientific discoveries. What he said about his own field is no different from the act of screenwriting – even great ideas need sweating over. Talent needs discipline and nothing happens by chance.

The passionate desire to see your dreams on the screen will count for nothing without the ability to translate those dreams into words – and get those words down on paper. Learning how to do this requires concentration, patience, persistence and most of all, stamina.

If you really want to write that screenplay, you must be prepared to invest the necessary time and energy. This will almost certainly be more time and energy than you expect. The one essential attribute every writer must have is the stubborn, bloody-minded determination to stick at it.

'True originality is hiding your sources' (Albert Einstein). Generating ideas can be the hardest part of screenwriting and it's about more than staring at a computer screen.

Film is a funny business – a curious conflation of art and industry, where fantasy and finance collide.

There are very few creative activities quite as complicated, long-winded or expensive as making a movie. It takes huge resources and dozens (if not hundreds) of people to bring a film to the screen.

**Barton Fink
(dir: Joel Coen 1991)**

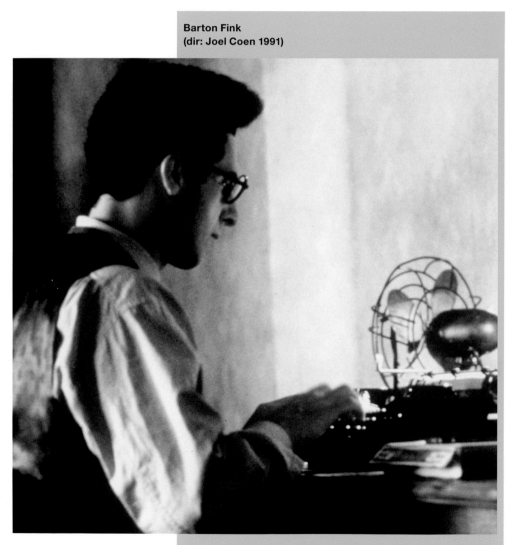

'What don't I understand?' His head full of youthful ideals, New York playwright Barton Fink is bewildered by his inability to write that Hollywood screenplay.

The role of the screenwriter

The role of the screenwriter is to give all these people a starting point from which to work – to provide the initial stimulus for the project. **Producers** want a bankable commodity, directors want compelling drama and actors want challenging characters to play and great lines to speak. It is the scriptwriter's job to deliver this raw material – which is then converted into the finished product we see in the cinema or on TV.

The writer initiates this process, but seldom 'sees it through' to its conclusion. While at his or her desk, everything is under the scriptwriter's control; but once the script is complete, it usually becomes the 'property' of others.

Working with others

Film-making is a collaborative enterprise and, to reach the screen, a screenplay must pass through the hands of directors, **cinematographers**, actors and **editors** – all of whom apply their own skills and impose their own interpretation. So it is hardly surprising if the finished film often looks very different from the original 'vision' that first took shape in the screenwriter's mind.

The screenwriter has a peculiar status. The legendary movie mogul Irving Thalberg said the writer was the most important person in Hollywood. Yet writers frequently complain at being unappreciated and powerless. What writers do have, however, is the truly extraordinary power to plant their dreams into the minds of millions.

The appeal of movies remains a simple one: to sit in the dark and be told stories. Someone has to write them; why not you?

Glossary

Producer: the individual who is with the film from the start of the process. The producer's primary concern is finance and with that goes logistics. At the start of the process of film-making, the producer will be responsible for selecting key members of the crew and at the end of the process will be responsible for distribution. Producers will often be the first significant industry professional to read your script.

Cinematographer (sometimes known as the director of photography/DoP): this member of the film-making team is head of lighting and camera and is responsible for the film's aesthetic, along with the director.

Editor: works as head of the post-production crew. Alongside the director, they edit shots and often sound.

Fortune favours the gifted, but only when they're brave enough to share their work with the world.

Marsha Oglesby

Glossary

Dialogue: the written form of speech intended to be spoken by characters and/or as a voice-over.

Writing for the screen is the same as other acts of writing. Many texts will supply you with thoughts, advice and guidelines for this process. One thing you will discover is that no one piece of advice is the same as the next. Nor will one day require the same discipline as the next. While you find your own rhythm, there are a few things that you should bear in mind:

Basic rules

No one can teach you how to write, and there is certainly no magic formula. Writing cannot be reduced to an exact science. Nevertheless, there are some basic rules that are quite straightforward. These rules may appear restrictive at first, but they actually provide a framework within which there is a lot of freedom.

- Learning rules is often boring, and many aspiring writers think that breaking them will immediately make their script original. And so it will – but there's a very high probability it will make the script both original *and* bad. Learn the rules before you start breaking them.

- You can't be innovative unless you have already mastered the basics. Quentin Tarantino made his name with *Reservoir Dogs* (1992) and *Pulp Fiction* (1994); but the first film he wrote was *True Romance* (1993), which has a completely conventional structure and story.

- One rule you must never forget is that in writing for the screen you are writing for an audience. Film is an act of communication aimed at someone else. Unless the needs, desires and expectations of the audience are taken into account, the chances are they won't get what you want to give them.

- A screenwriter is a dramatist producing characters, situations, action and **dialogue** to create atmosphere, intrigue and suspense. You are inviting an audience to share a world you have created, and to follow your characters on a journey through that world.

- As a writer you have to do more than just issue an invitation – you have to make your audience attend and involve them in what is happening on the screen. Good writers know how to grab an audience's attention, keep hold of it and control it for the duration of the film.

- The art of screenwriting is being able to evoke very specific thoughts and feelings in the viewer. This means carefully choosing the right word, object or action that will transmit the necessary information or provoke the desired response in the audience.

All this requires a lot of detailed and strategic thought. Failure to think through your aims with regard to the audience will probably cost you a lot of time, whereas careful reflection on the nature and quality of the experience you are aiming to give them is always time well spent. Never stop asking yourself: what impact is this having on my audience?

Showing a story

Successful screenwriters know which buttons to press and what happens when you press them. In addition to knowing what makes your characters tick, you need to know what makes your audience tick! Writing is an elaborate psychological game intended to manoeuvre them into particular states of mind; curiosity, sympathy or anxiety, for example. If played properly, the audience are unaware that they are being manipulated. Nor do they care – it is all part of the fun.

Screenwriting is telling a story using pictures. Dialogue plays its part, but film is a predominantly visual medium. Writing a screenplay is therefore a 'double procedure' that involves writing words on the page to produce events on the screen. Getting the hang of this is a gradual process. As a screenwriter, you are essentially dealing in words but thinking in pictures.

Whether telling jokes or inducing terror, as a writer you are in the entertainment business. Luckily, 'entertainment' takes many forms, from the lightest comedy to the most gruelling naturalistic drama. The pleasures are different, but the obligation remains the same – to feed the public's appetite for being moved, amused and amazed. Note to self: this does not necessarily mean pandering to popular 'taste'. Most 'successful' films are pizza – but the odd piece of sushi can take the world by storm.

**The Purple Rose of Cairo
(dir: Woody Allen 1985)**

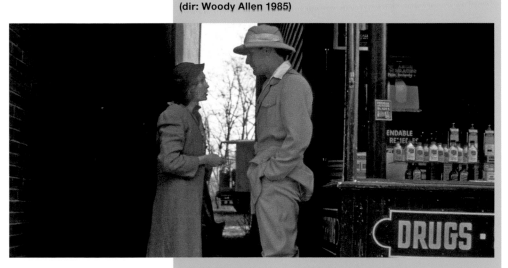

As a screenwriter, you are painting characters on to the broad canvas of the screen. Great characters step straight off it – and into the lives of the audience. In Woody Allen's *The Purple Rose of Cairo*, the leading man does just that – literally.

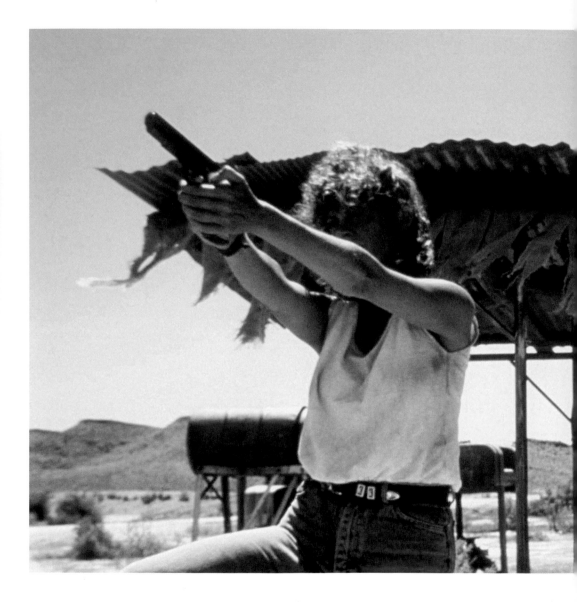

**Thelma and Louise
(dir: Ridley Scott 1991)**

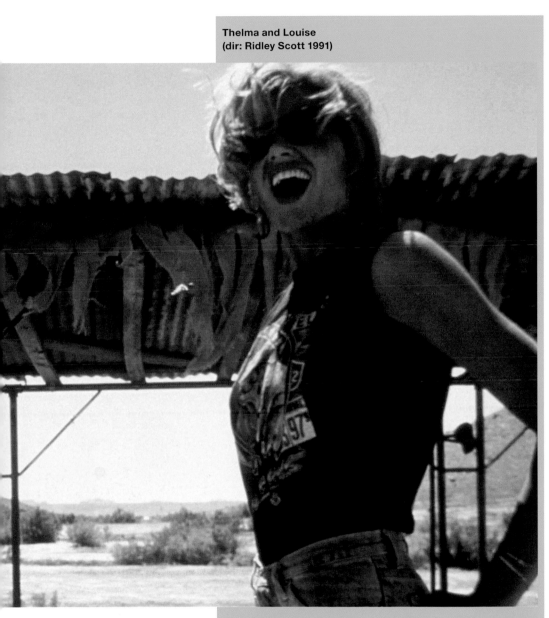

A movie sends the audience on an adventure. As a screenwriter, you
must have a clear idea about where you want to take them, and how
you are going to get them there. Will it be a stroll in the park, a walk
on the wild side or a voyage into the unknown? *Thelma and Louise*
does just this – on a literal and a conceptual level. They go on the
traditional road trip (subverting what was a male genre), but it is
also a journey of discovery. That's one reason why the ending
remains so contentious.

A screenplay is an unusual document. Typically, it comprises around 120 pages – wide-margined and sparsely typed. There isn't a great deal to show for all the effort the writer has poured into it, and few (if any) people will read it for its own sake. A script really exists to enable something else to happen. It is a blueprint from which something much bigger and more spectacular is made.

The script as instruction manual

At a functional level, a script is a set of instructions. It tells actors what to say; it tells a set designer what to build; it tells a sound recordist what to record. It provides the director with a guide to what shots they will need to use. It is a device for promoting, harnessing and steering other people's creative energy. It can tell almost any story, it can build any world.

A film script is often likened to a musical score. It has its own special notation, and requires the specialist skills of other people to realise its potential. Film is orchestrated for numerous 'instruments' – cameras, lighting and sound equipment, the human body and the human voice – each taking its cue from the information presented in the script.

What is more, film is a multi-channel medium that can deliver all these impressions at the same time. Any single moment in a film is composed of light, movement and sound – all playing simultaneously upon the audience's awareness. Many things can be going on at once.

Script is to film what choreography is to dance. For the director and actors, the script lays out the essential steps in the relationships that make up the 'human interest'. It maps the psychological territory across which the characters travel. Quite apart from the physical events that make up the plot, it is this emotional journey that is the real story the viewer follows to its ultimate destination.

Movies present the surface patterns of human behaviour – external action and spoken language. What film struggles to convey is the inner world of characters – internal events and inner voices – the invisible life of the mind. These can only be revealed indirectly.

A film script is a text to be produced. It strives to fix some things firmly in place, but it cannot dictate how they are finally realised on the screen. That is the province of others. The script can dictate the lines, but not how they are spoken. It can describe an action, but not the way the actor will do it. You cannot direct a film from your laptop.

This does not mean that, as a writer, you can afford to be vague about things. On the contrary, it is only when everything is clear in the scriptwriter's mind that it will all hang together and make sense on the page. The design has to be complete when it leaves your desk. This is what the film-maker expects, even if they may feel it is necessary to alter something in the script later on.

It isn't the responsibility of the writer to produce these images, but it is important to know how film works and how it controls its audience by narrowly focusing their attention on specifics.

Resist the temptation to include every pictorial detail and to advise the director on camera angles. It is a waste of time. As the screenwriter, you must concentrate on producing scenes for actors to play. However, to do this effectively you must be able to visualise your film, and think 'cinematically'.

The finer details

Only describe what is important for the story. It is no good writing that 'the audience begin to sympathise with character x and become suspicious of character y'. Your task as screenwriter is to manufacture this sympathy and suspicion, which can only be done by delineating what is seen and heard. It's no good stating that 'x has seen better days' or that 'y secretly wants to kiss z'. The audience watching the screen is only going to know this by virtue of how the characters look, what they say or what they do.

Telegraphic storytelling

A screenplay lays out the **narrative** spine of the film. Typically, movies are fractured into numerous small (sometimes minuscule) scenes – quite unlike a piece for theatre. Learning how to use this minimalist, 'telegraphic' style of storytelling is fundamental to the art of successful screenwriting.

This book uses short film as a handy vehicle for developing scriptwriting skills. Almost every problem facing the writer of feature film and TV drama is encountered in producing a short film script, with the added advantage that one can experiment and learn very quickly. Short film is a test bed where you can try out ideas, learn your craft and hone your skills.

Short films are the best calling card a novice writer/film-maker can have. Famous directors such as Roman Polanski, Martin Scorsese, Mark Herman, Shane Meadows, Steven Spielberg and Ridley Scott cut their teeth making shorts. Contrary to popular belief, *Citizen Kane* (1941) was not Orson Welles's first film – that was a five-minute short made when he was 18 years old.

Good short films are as arresting, evocative, thought-provoking and unforgettable as a good feature. What they lack in length, they can make up for in depth, subtlety or sheer energy. A short film should punch above its weight and leave a lasting impression on the viewer.

Dead of Night (1957) and *New York Stories* (1989) are compendia of short films. It would be a useful exercise to speculate whether any of these short flights of fancy could be converted into the long haul of a feature film.

Shorts

Shorts have to be even more ruthlessly efficient, streamlined and fat-free than features. In this sense, short film is film *par excellence*. Free from the expectations created by a big budget, short films can also afford to be less formulaic than most cinema/TV products. You can take risks and bend the rules – a little.

Narrative in short film should be strong, but simple.

Beginners are often tempted to invent the most complicated stories, with intricate twists and turns that are difficult to explain, let alone 'bring off' on screen. This usually leads to a host of other problems, such as gaps in the **plot**, inadequate characterisation, and endings that are too enigmatic. Your film must fit the available space. It can take a long time to make it short enough.

By far the most common error when writing a short film script is trying to force feature-length detail into 15 minutes. Movies such as *Terminator*, *Sleepless in Seattle* and *Memento* are as long as they are because they simply couldn't be shorter. They require time for the chase to run its course, the lovers to find one another and the murderer to be uncovered. **Feature films** are relatively 'slow burn' – and lay down a long fuse of suspense. Short films have to ignite more quickly, and work on their audience in an even more direct and abbreviated way.

Character is still important, of course – in fact, it's crucial – but there is less time to dwell on what makes your characters who they are. It is only this moment in their lives that counts, and what they will do with it. Typically, shorts shine a narrow beam of light into a dark corner of reality, exploring human nature through an individual's reaction to a single dramatic event or situation.

The most powerful thing in any film is raw human emotion. This is what audiences respond to most strongly, whatever the length of the film. Emotion takes many forms and expresses itself in many ways. Unbearably intense passion can suddenly erupt and overwhelm your characters, as in the opening sequence in *Don't Look Now* (1973); or quietly smoulder beneath the surface as in *Brief Encounter* (1945). The best short film scripts exhibit all the qualities we look for in a feature film screenplay – a compelling narrative, dramatic tension, arresting images and crisp dialogue.

Glossary

Feature films: normally 90 minutes or more in length and often characterised by more locations, characters and particularly subplots than short films. They are usually intended for cinema release.

Lindsay Doran (producer), James Schamus (co-producer), Ang Lee (director) and I met previously this month to discuss the latest draft of the script, which is what we're all here to work through... Lindsay goes round the table and introduces everyone – making it clear that I am present in the capacity of 'writer' rather than actress, therefore no one has to be nice to me.

Emma Thompson

What is a script? > **Script forms – feature film / short film** > Good practice

The difference between features and shorts

In the majority of cases, feature films:

- Are between 90 and 120 minutes long
- Have a fairly rigid three-act structure – beginning, middle and end – in that order
- Have a large cast of characters
- Tell us the background and the story of the main characters in some detail
- Tell a story that is resolved in some way by the end of the film
- Can tell a story that takes place in many locations over a considerable period of time
- Have sub-plots running parallel to the main plot

Short films as a rule:

- Are rarely more than half an hour long, and can be as short as a minute
- May use a three-act structure, but one that is far more flexible than that of a feature
- Focus on a very small number of characters
- Paint their characters with broad brushstrokes
- Can leave the story unresolved
- Have a restricted number of locations and action taking place over a short time period
- Don't use sub-plots

Too Many Nuns Spoil the...
(York St. John University)

The scriptwriter is normally one person plugging away. Bear in mind that it takes many people to bring the script to life. They each have their own job to do, and must remember not to tread on others' toes.

Do's and don'ts – developing good practice

Do:

- Get into a regular routine and stick to it. Most writers are creatures of habit.
- Accept the fact that you will have bad days. They are inevitable – and you always learn from them.
- Avoid distractions. Time is precious; don't allow it to dribble away.
- Buy a voice recorder for those thoughts that will be gone before you've had the chance to find a pen and paper.
- Focus on specific tasks and complete them before moving on to the next thing.
- Backup your work regularly.

Don't:

- Just write when you 'feel' like it. Treating it as a job may seem mechanical, but it will yield results.
- Give up just because you've had a bad day. The chances are that tomorrow will be a good one.
- Play computer games, answer emails or surf the net. If you're unable to write, watch a movie.
- Throw away notes or delete files if you don't have to. You never know when you might need them again.
- Try writing two scripts at once. You won't be giving either of them your best.
- Lose faith. If it was easy, everyone would be doing it.

There may be no magic formula for success, but there are plenty of practical tips for the fledgling screenwriter trying to get started. And the first tip is to start where you are – and tap into what you already know.

The film fan as writer

As a fan of the movies you will be immersed in the language and logic of mainstream film, and already have an intuitive sense of how they 'work'. When you start to write, this implicit awareness of shape and rhythm will guide you to some extent. But in order to think constructively about your writing, you ultimately need to make this knowledge *explicit*.

The way you watch movies will have to change. It is no good passively soaking them up any more. As a writer you need to engage in *active viewing*, which involves asking questions all the while. How is this character created? What is the function of this scene? Why is that line so effective? Why did it make me cry/shudder/jump/cheer?

Normally when watching a film, we are meant to identify with the hero. Now you need to train yourself to identify with the writer instead, and examine what *they* are trying to do. Every film has something to teach you – even if it is what *not* to do.

Find screenwriters whose work you admire. Although films are usually credited as the work of a particular director, it is the writer you need to study. The screenplays of William Goldman (*Butch Cassidy and the Sundance Kid*, 1969), Paul Schrader (*Taxi Driver*, 1976), Robert Towne (*Chinatown*, 1974) and Carole Eastman (*Five Easy Pieces*, 1970) represent masterclasses in the art of writing film.

Find pieces of film you particularly admire, and be prepared to take them to bits to see how they work. For instance, the parlour scene in Alfred Hitchcock's *Psycho* (1960), written by Joseph Stefano, is a classic case of characterisation and dramatic development. Scenes like this repay repeated viewing.

When thinking properly about a particular scene, you need to see it clearly in your mind's eye and hear everything you want the audience to hear. When imagining a scene you need to run it in your head in real time. How else can you be precise about the emotional weight or the pace of the action?

Writing requires research. When your film touches on areas outside your immediate experience, you need to make sure you are on firm ground. This is why practised writers tend to gather a lot of wayside information, knowing a little bit about almost everything. For example, if your subject is crime and detection, you need to know quite a lot about police procedure and have the right vocabulary for describing it. Don't rely on what you have already seen on TV – go and find out for yourself.

Keep a notebook or shoebox for catching scraps of life – half-formed ideas, fleeting images, fragments of personal detail, snatches of overheard conversation and curious observations. Make a point of going through it every few months – you'll be surprised what you have collected and at how the most disparate material can come together.

Lastly, be yourself. Plenty of beginners start by trying to copy someone else. The problem is that it is difficult to keep it up. Write out of your own personal desire. Nothing else works. Find something that interests you – a story, a **genre**, a character, an idea – because this will anchor and orientate you when things get tough. And from time to time, they *will* get tough!

Glossary

Genre: the name given to the characteristics, stories, and/or aesthetics that link films (often of different countries and different periods).

**Psycho
(dir: Alfred Hitchcock 1960)**

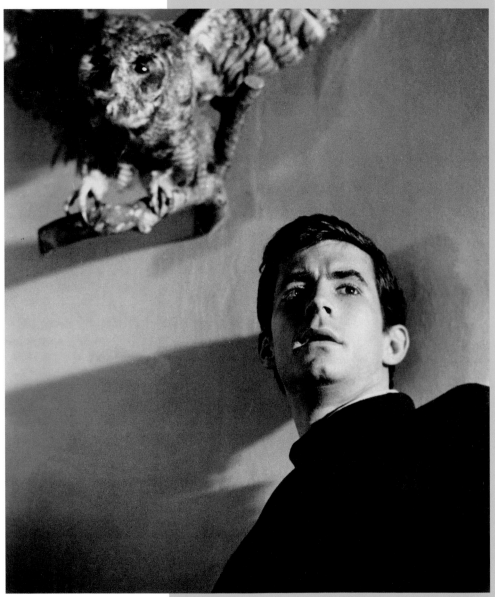

This scene in Hitchcock's *Psycho*, where Norman Bates entertains Marion Crane, is an object lesson in how to define character and generate tension. What we see and hear – the stuffed birds and Norman's description of his mother – convey dark, unseen and unspeakable things.

Rules of thumb for the budding screenwriter

As a writer you must:

- Write with a purpose. Know what your intentions are at any given moment.
- Develop your interests in other things, and seek to draw them into your writing.
- Cultivate your fantasy life. This is the soil out of which your writing grows.
- Observe and listen to everyday reality – it is far stranger than any film.
- Read your work aloud. You are writing for the voice – your words are meant to be heard.

As a writer, you should never:

- Wait for inspiration. It only comes when you are doing something else. Just jump in.
- Sit in front of a blank screen. Move some words about. Get some 'black on white'.
- Forget the value of just fooling around. Writing is a form of play, with words, voices, characters and pictures.
- Forget to have fun. If you don't enjoy writing it, why would someone else enjoy reading it?
- Be entirely satisfied. There are always improvements you can make. Keep plugging away.

Every film starts life as a pretty flimsy idea. The fact that something so fleeting and insubstantial can give rise to so much magic and mayhem – not to mention money – is one of the alarming things about the movie business.

New screenwriters often fret over story ideas, as if they were hard to come by. They aren't.

They are everywhere. We are saturated in stories – morning, noon and night. Alternatively, they can hang around for years – odd notions that keep pestering us for attention. Here it is a matter of figuring out why it has got snagged on your imagination – and whether there is really a film in it.

You can obviously find ideas in personal experience. The advantage is that it is already vivid and readily connects in your mind with other people, places and events. Unless you are already famous, an autobiographic **screenplay** probably won't have much mass appeal, but a fragment of your own lived experience can still take off into unlived realms.

Real historical events may spark your imagination. These subjects require heroic amounts of research and often fit uneasily within a cinematic framework, but films such as *All the President's Men* (1976) and *Titanic* (1997) have additional force because they are based on real events and re-enact our shared past.

You can turn for inspiration to existing stories. Approximately half of all UK and US films are adaptations – usually novels transferred to the screen. Literature and theatre provide a treasure trove of material to plunder. It can seem a very tempting proposition – even easy – because there are so many words already there to work with. However, transferring a novel onto the screen requires additional skills, and few if any writers would start there.

Having said that, it is debatable whether *any* film or story is strictly speaking completely 'original'. Arguably any piece of writing involves the manipulation of existing material, whether it is the words in the dictionary, the typical behaviour of human beings, or the repertoire of narrative conventions that belong to the form – none of which we invent for ourselves. And who could come up with a 'new' story?

Archetypal stories account for the plots of *Citizen Kane* (1941), *Brief Encounter* (1945), *The Godfather* (1972), *Rocky* (1976), *Superman* (1978), *Sleepless in Seattle* (1993), *Memento* (2000) and every road movie you have ever seen.

Glossary

Screenplay: the alternative term for film script, which is also often used to refer to television scripts.

**Dead of Night
(dirs: Alberto Cavalcanti, Charles Crichton et al 1945)**

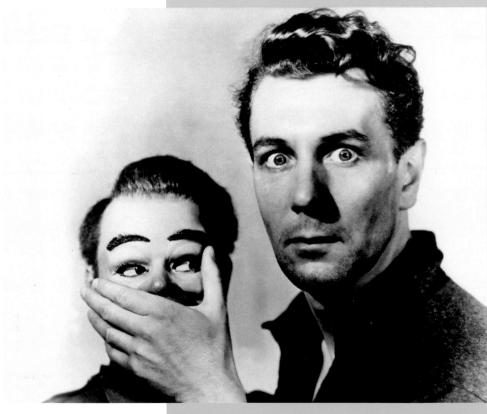

A story idea may take the form of a hypothetical question, a 'what if…?' What if a ventriloquist's dummy started to speak for itself (*Dead of Night*)? What if an asteroid the size of Texas was about to hit the Earth (*Armageddon*, 1998)? What if there was a bomb set to explode if a bus were to travel slower than 50 mph (*Speed*, 1994)?

Good practice > **Finding your ideas**

Finding the extraordinary in the ordinary

None of the previous films mentioned set out to retell an ancient story – the point is they couldn't much help it, and neither will you. It isn't necessary nor advisable to make this your intention, but once you have your story it will surely follow a similar path.

For similar reasons, short films often take the form of little fables or parables – small stories with mighty resonance. Catch sight of the underlying theme or irony and you can direct the narrative impulse behind your story more effectively.

Short films frequently arise from an unusual slant on familiar phenomena, and make us look at the familiar in a new way. A talent for spotting the strangeness of everyday things is a great gift. You don't need the exotic locations or sweeping panorama of a feature film to explore the curious obsessions or absurdities of daily life. What is most fascinating or fantastic is often closest to home. Find the extraordinary in the ordinary and the ordinary in the extraordinary, and you will have an audience in the palm of your hand.

An idea might come from seeing someone in an unusual situation or dilemma. Better still, from observing two people with two different dilemmas. This was the starting point for Hitchcock's classic thriller *Strangers on a Train* (1951). Two men strike up a conversation, and one of them suggests they solve each other's problem with a murder. From such a beginning, any number of films could ensue.

Archetypal stories

Fictional characters are constantly:

- Being heroic (but flawed), like Achilles
- Swapping rags for riches, like Cinderella
- Flying too high, like Icarus
- Losing something precious, like Orpheus
- Making pacts with the Devil, like Faust
- Falling in love, but being held apart, like Romeo and Juliet
- Falling in love yet staying apart, like Tristan and Isolde
- Trying to get home, like Odysseus

**Memento
(dir: Christopher Nolan 2000)**

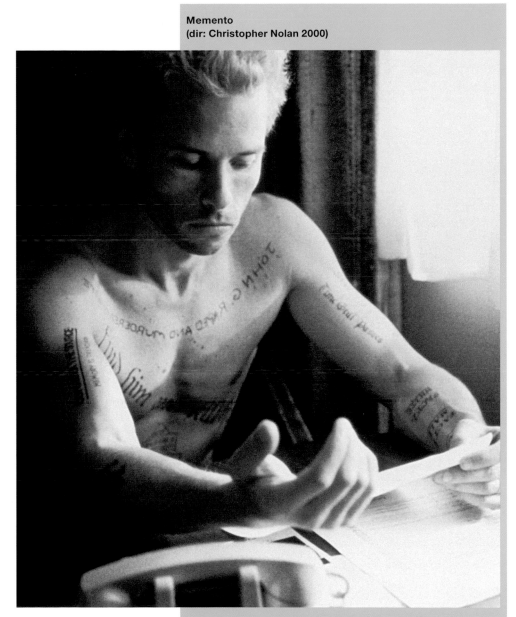

Nobody knows where ideas come from – but come they do!
The difficult thing is to capture them in flight and pin them down.
Of course you don't have to go as far as Leonard Shelby. *Memento*
is a familiar story, a murder mystery. The concept is an innovative
one – putting the main character in the same position as the
audience. This aspect of the film is far more interesting than the
reverse chronology that operates throughout it.

Where do ideas come from?

On close examination, even the newest story is really a retelling – albeit in different costume – of an old one.

Conflict as the core of good drama

Conflict is the engine of any story. It drives things along. Characters must have desires that put them at odds with reality. They are individuals pitted against other individuals, or society, or the natural world, or their own conflicted nature – facing resistance, opposition or an open threat. The origin of the conflict and how characters respond to it determines the empathy or amusement the audience feels. Find a struggle and you have a story. Latch on to a character, give them an obstacle, and find ways of frustrating them until the penultimate page.

Hardly less staggering is the idea of a man with only his short-term memory intact trying to solve a murder. Add to this the notion of telling the story backwards and you have the fascinating scenario of Christopher Nolan's *Memento* (2000). The intriguing challenge presented by a film that jumps backwards in 10-minute segments is an integral part of its initial conception.

Of course, most ideas are far less involved and intricate than this. They might come from a funny remark, suggesting a curious relationship or eccentricity. A casual exchange heard in the street or one half of a phone conversation can summon up a world of possibilities. Films such as *Withnail and I* (1987) and *Trainspotting* (1996) are full of sharp or oblique one-liners that help to define a character or a relationship.

Alternatively, you might focus on a place or an object. Martin Scorsese's *Taxi Driver* (1976) is dominated by dazzling city lights seen through the windows of a New York cab. As it glides and snarls through the rain-swept streets, it defines Travis Bickle's detached and distorted view of the world. Jane Campion's *The Piano* (1993) has its origins in an equally symbolic object of desire, set in a remarkably incongruous landscape.

Tim Burton's *Edward Scissorhands* (1990) was nothing more than a childhood drawing, until the scriptwriter Caroline Thompson recognised the character as a wonderful metaphor for the pains of human intimacy, and found a story framework to house him.

No matter how slight, as long as the idea – character, scenario, image – is strong enough to hold your attention, it can provide a launch pad to who knows where.

The idea

This is the stage where you can let rip – unfettered by practical considerations. If you are planning a short film script, you must, of course, make sure the idea 'fits the space', but in every other respect you are free.

Coming up with the right story line – the right atmosphere, the right degree of complexity – *is* difficult, but almost infinite resources surround you. And once you have that core idea or concept – the rest is only bloody hard graft.

A screenplay, I soon realized, is a story told with pictures. It's like a noun: that is, a screenplay is about a person, or persons, in a place, or places, doing his, or her, 'thing'.

Syd Field

EXERCISES

In trying to generate a story idea try the following exercises:

Write the outline of a chase story. One person (or persons) is trying to run away: the other person (or persons) is trying to catch them. Location and motivation are completely up to you.

Sit in a café or a bar and listen (careful how you do this) to a snatch of conversation. What is the 'story-world' that surrounds what you hear?

Two cars collide at a junction. It is up to you to decide how bad the accident is, who is in the cars and what happens to them.

But first you must explain who the people are and how the cars came to be in the same place at the same time. Then decide whether this incident marks the beginning of your story or characterises the end.

Get a photo of a person you don't know – it could be from the Internet or from a newspaper. Write a brief biography of the character – no more than one side of A4. Then write another side of A4 about the most significant thing that ever happened to them in their life.

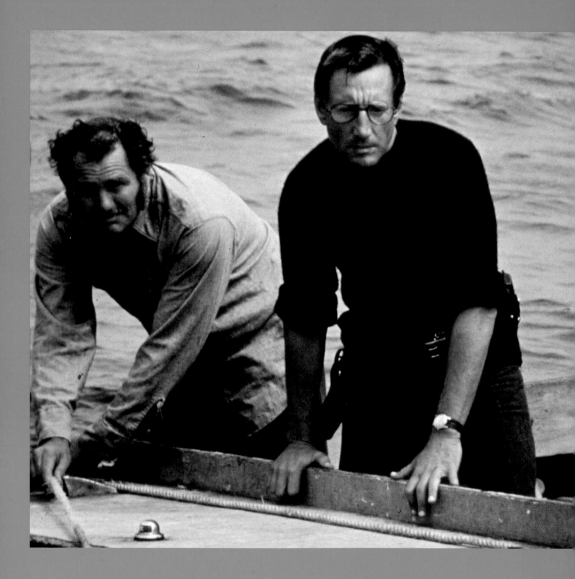

CONCEPT/TREATMENT/PITCH

Jaws
(dir: Steven Spielberg 1978)

Shark attacks island: *Jaws* has an apparently simple concept behind it. Actually, the concept is about much more: friendship, honour, comradeship and masculinity. Whatever your initial concept, you are definitely going to need a bigger boat.

You now have your idea and no doubt at this stage it has been rushing around the inside of your head for a while. You have, most likely, discussed it with other people who have made comments on it. You've listened to some and rejected others and forgotten more than you've remembered. There comes a point where the thinking stops and writing starts. Preparation is essential and setting parameters is crucial, otherwise the scope of your idea will spiral out of control before you've begun putting pen to paper (or fingers to keyboard).

When thinking about structure, it is important to have a sense of the theory as well as the practice of screenwriting. The best film-makers are often those who are students, formal or informal, of their own modium; for cxample, Spike Lee cites Budd Schulberg as a significant influence on his work. Reading and viewing are essential precursors to the act of writing.

Structure is utilised as well as created in a number of ways by the successful screenwriter. Using a structured process will aid you in creating the most effective structure for your script and thus for the director and ultimately your audience. For an audience, your structure should be hidden and the film should appear natural.

We are so versed in the language of film that we don't see how it is constructed. As a writer, you need to see and use structure.

The essential elements of storytelling are all about how an audience understands the story and how they will derive meaning from the flickering images on the screen. As a screenwriter, you have the added problem of getting across the meaning to both a producer and a director before they stamp their mark on your work. Once you have written your script and passed it over, you no longer have any control over it – it has to be precise. Precision is about reining in the parameters: this is where structure is of paramount importance.

Structure

Structure is the glue that holds a film together. Most feature films are based on a fairly rigid three-act structure; short films can be more experimental. Nonetheless, it is important to know and understand the classic three-act structure before starting on the writing of short films. Certain structural rules apply to both features and shorts.

The classic three-act structure

Act one

Act one is the set-up. It introduces the characters and the situation. In *The Terminator* (1984), we see the Terminator and Kyle Reese arrive in present time. We meet Sarah Connor, the heroine, learn about her day-to-day existence and discover that her life is under threat. In *Jaws* (1975), we see there's a very big shark out there, and we're introduced to the town and to Chief Brodie.

At the end of act one, plot point one occurs.

Plot point one

Plot point one is where the story of the film actually starts, and should define what the story is about.

In *The Terminator*, it's easy to spot. The Terminator has tracked down Sarah Connor; but just as he's about to kill her Reese appears, blows the Terminator off his feet, grabs Sarah and drags her away with the words: 'Come with me if you want to live.' This scene essentially sets up the story of the film.

In *Four Weddings and a Funeral* (1994), it's also fairly easy to identify plot point one. The movie is about a man who's afraid of commitment but meets a woman he would like to commit to. Plot point one is where he sleeps with her for the first time.

Classically, plot point one poses the question or sets up the problem. The rest of the film is about how the question is answered or the problem solved. In both *The Terminator* and *Four Weddings and a Funeral*, tension is generated and thematic questions are asked, such as 'what will happen next?' and 'why are these events happening?' We are being taken on a journey.

Act two

Act two contains the main body of the story. In a chase movie, this is where the chase will happen. In a romance, this is where the couple will fall in love, fall out of love, fall in love again and so on. In *Four Weddings and a Funeral*, it is the story of how the relationship develops between Charles (Hugh Grant) and Carrie (Andie McDowell). In *The Terminator*, it is about the efforts of Sarah Connor and Reese to escape from the Terminator.

At the end of act two, plot point two occurs.

Plot point two

Plot point two is the confrontation. In a chase movie, plot point two is the point when there's nowhere left to run; you have to stand and fight. In *The Terminator*, it's the final confrontation at the automated factory: in *Jaws*, it's the bit where the shark sinks the boat.

If the film's a romance, it is where the hero gets the girl or the heroine wins the boy. It's Charles jilting Henrietta (Anna Chancellor) at the altar in *Four Weddings and a Funeral,* or Mark Darcy (Colin Firth) laying out Daniel Cleaver (Hugh Grant) in *Bridget Jones's Diary* (2001).

Plot point two is probably the easiest thing to spot in a film – any film where it's not obvious is in deep trouble. Plot point two resolves the problem posed by plot point one – the monster is destroyed, the murderer unmasked, the meaning of true love revealed. It leads on to act three.

Act three

Act three exists to tie up the loose ends and the general rule is, the quicker the better. The classic quick act three is in Hitchcock's *North by Northwest* (1959), where he resolves everything in a series of very fast shots. In the area of romantic comedy, a very well put together ending is that of *Four Weddings and a Funeral*. It is quick, answers all of the questions and shows that everything ends happily through a series of snapshot stills.

Though act three is easily the shortest of the three acts, it shouldn't be neglected. A good, sharply written and well-constructed ending means the audience will leave the cinema on a high – and tell all their friends what a good film they've seen. Get it wrong and you can undo a lot of the good work you've put in on the previous two acts.

Essential elements of storytelling > Theories of storytelling

How does the three-act structure apply to shorts?

Short films allow for far more experimentation than features, especially in terms of structure. It is possible to construct a short with a three-act structure but, very often, the first and third act become very attenuated. Sometimes it is impossible to discern a conventional structure at all.

If you look at either draft of *A Nice Cup of Tea* (pages 174 and 186), you will see that the first act is extremely short. The story is about a man's quest for a nice cup of tea and how his failure to obtain one illuminates all the other things that are wrong with his life.

It is easier to spot the first act in the first draft. We are introduced to Keith and we hear his wish for a properly made cup of tea. The story proper begins with his first failure to obtain one. The second act is a series of short sketches showing how he fails in every attempt he makes to gratify his desire. Act three consists of his finally getting his wish – and then being executed.

A lot of short films fall into this category – very short first and third acts with the film being almost entirely made up of the second act. *About a Girl* (2001) is an excellent example. Some short films do not conform to the three-act structure at all, such as *Yoorinal* (2000) and *Where's the Money, Ronnie?* (1996). However, this does not mean that you can forget about structure. The fact that short films allow for experimentation doesn't mean that anything goes. Audiences like being intrigued; they don't like being confused. If your film is focusing on one or two characters, then you'll need to establish them very quickly – the short *Je t'Aime John Wayne* (2000) is worth watching to see how this is done. Dealing with one character can be particularly tricky: examine the short film *Flapwing and the Last work of Ezekiel Crumb* (2006), *Floored* (2008) or *Snowed Under* (1936) to see how plot development occurs.

The structure should also allow for escalation. If a character has a problem at the beginning of the film, it should get worse as the film progresses. In *A Nice Cup of Tea,* Keith's life is not in good shape at the start; by the end it has fallen apart. In the British short *Dupe* (2005), a man buys a cloning machine in order to reorganise his life – but it simply makes things more difficult.

Flapwing and the Last Work of Ezekiel Crumb
(dir: Alasdair Beckett-King 2006)

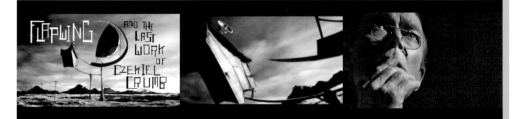

In this series of images, Crumb sets to thinking after meeting Flapwing for the first time. *Flapwing* is an interesting and valuable example of the three-act structure. The premise has been established, all characters have been introduced and the plot can then be developed. Without this clear establishment of character, the plot would not work.

Floored (production still)
(dir: Alisha McMahon 2008)

Structure is vital, but imparting it simply is essential. In *Floored*, the apartment block is the setting and the 'character' of this setting is key. In the script, this comes from the interaction between character and setting. The latter is: 'a corridor described as a dark and long hallway with peeling wallpaper. A light is visible from a window.' The descripion is simple – but effective and evocative.

Essential elements of storytelling > Theories of storytelling

Glossary

Syd Field: an American writer and film consultant. His book *Screenplay*, published in 1979, has been highly influential in expounding and popularising the three-act structure.

Narratology: a body of theory that examines and analyses narrative structures primarily in terms of form, but also in terms of content.

Roland Barthes (1915–1980): French semiotician. His work influenced the development of theories of structure and paved the way for popular forms, such as film, to become integrated within academic study.

Structuralism: the name given to a grouping of theorists and theories that analyse how various media (including film) are structured and how they communicate. It is an umbrella term that covers a range of subsets, including narratology.

There are multiple theories of screenwriting, such as those relating to the three-act structure as outlined by **Syd Field**. However, as the short film can be much more experimental in form, once you have got to grips with the rules for feature films, you can begin to delve into the body of theory that relates to narrative communication – the essential elements of storytelling. These theories are grouped under the heading of **narratology**, a branch of the structuralist movement. This is about much more than storytelling; it is about each essential element of the act of communication. As a screenwriter, you are dealing purely with written language, yet you have to communicate image, sound and text too.

There are many theorists who will be of use to you, including the granddaddy of all structuralist theories, **Roland Barthes**. A consideration of Barthes' Narrative Codes is a very useful exercise in examining how a broad narrative can work on an audience; likewise with the work of the godfather of film **structuralism** and narrative analysis, **Christian Metz**.

Gérard Genette's Narrative Discourse

Genette's Narrative Discourse is intended for all narratives in all modes. In this sense, he spends a great deal of time on **narration**, an aspect of the script development process that is all too easily overlooked and will be examined later in the book in more detail. Metz discusses types of narration that are open to the storyteller and forces consideration of the nature of the 'voice' at all points.

Story and plot

In the category of 'story', **Gérard Genette** identifies that a narrative has: characters, who do things; settings, which exist in a particular place and time; and events that relate to each other. It is this final category that best exemplifies plot. E. M. Forster expressed this along the lines of: 'the king died and then the queen died' is a story. 'The king died, and then the queen died of grief' is a plot. The most important thing this yet-to-be-bettered quote reminds the writer is that plots are created by causality; by the relationship between one event and another. If you don't make these connections, an audience will try and do it themselves and might create a meaning that you didn't intend.

This best exemplifies why the plot of a short film has to be simple. Try outlining the plots and subplots of a feature film and see whether you could compress this into a short.

Glossary

Christian Metz (1931–1993): French film theorist and semiotician. His book *Film Language* was hugely successful for its examination of film structure.

Narration: speech that can be from characters we see or from voice-overs spoken by a character or characters we may never see or meet.

Gérard Genette (1930 –): French narratologist. He is associated with the Structuralist movement alongside Metz. His work is not normally associated with cinema but provides an invaluable guide to narrative and a 'check list' for the practising screenwriter.

Five channels of communication

- The visual image
- Print and other graphics
- Speech
- Music
- Noise (SFX)

The most renowned film structuralist is **Christian Metz**. In his book *Film Language*, Metz provides tools for analysing films down to the smallest detail.

Metz's 'Five Channels of Communication' shows what appears to be obvious. The beauty of this chart, and of others like it, is that it states the obvious – an obviousness that we might otherwise overlook when embroiled in the act of writing. The key is to consider how these elements work together in every individual scene.

Making meaning

It is Genette's category of 'text' that is of most importance to the budding screenwriter (and narratologist). In this section, he deals with how meaning is restrained and communicated to an audience – without them realising it. He considers taking time to consider what we see or hear, when, in what order and for how long. This relates not only to the overarching narrative but to each individual scene, each piece of *mise en scène*. Focalisation is not only about your lead protagonist; it also forces questions about which viewpoint is presented. For example, when two characters are talking about a third who isn't present, they are still locating the audience in relation to that third character. In *The Apartment* (1960), we hear a number of characters discussing C. C. Baxter in unkind and disparaging terms, but this only makes us feel more for Baxter, rather than siding with the people who are speaking. Your audience should think they are free to judge what the story is saying to them; in reality, you have positioned them without them realising. This is done primarily through character.

Developing your concept – what is your starting point?

Consider which of these three images would form the basis of your idea. Is it the image that focuses on character? Is it the image that focuses on landscape but shows the means of communication? Is it the landscape in which you have to create characters? What traits and attributes would you give to the character in the first image? Do you have to introduce other characters in order for actions and interactions to make sense?

Thinking about character and character biographies

Philosophically, it could be called 'ontology of character', in practical terms it's making your characters real, three-dimensional beings. Genette calls this ascribing 'traits and attributes', or behavioural characteristics. These modes of behaviour are what make an audience relate to characters. It also differentiates between characters who are characterised and characters who are essentially part of the setting. Woody Allen's *Manhattan* (1979) has hundreds of people in it, but few characters. The people form part of the cityscape that is central to the film. Given the amount of time it takes to characterise, shorts have less characters than features.

Early on in the process of developing your idea, it can be useful to provide three dimensions for your characters in order to characterise them. This allows for logical behaviour as your script develops. You won't use all the detail, but it is important that you know it. The form and genre of the film are important, as this may dictate how the characters behave. Their reality is the reality of cinema.

Gérard Genette's Narrative Discourse

STORY (the content plane)

Events	chronology/causality
Characters	actions/interactions
Settings	spatio temporal complexes

TEXT (the presentational plane)

Time	order/duration/frequency
Characterisation	traits/attributes
Focalisation	who sees and judges

NARRATION (the telling plane)

Type	reliable and unreliable
Level	embedded (speech vs. voice-over)
Voice	narrator/character

Gérard Genette is a theorist, linked to the Structuralist movement. Much of his work is literary in emphasis, but provides a useful checklist of the essential elements of narrative. Genette is one of a body of theorists whose work is grouped under the heading of narratology: essentially the systematic study of narrative.

One of the aspects of film that attracts an audience is a recognition of the genre and form that the film will take. Genres are referenced in publicity and sometimes by film festivals. An audience may use genres to determine which film they might view. A studio might select a genre piece because it is popular at a particular time and thus will make money.

As a writer, you will be looking to genre and form because they provide a set of rules. You might use the conventions that are available to you or you might tweak them to create something new. Whatever the reason for using them, the fact is that you *will* use them.

Genre

Genres are established over time and are used for many reasons. Audiences are familiar with genres and the look and structure they have. They can be limiting but they can also provide you with the vocabulary you can use, as with *Film Noir* (2007) and *Chinatown* (1974). These films use specific periods in history, particular narrative structures and character types – the anti-hero and the femme fatale, for instance.

Film companies like genres because they provide them with a marketing tool and build audience expectations. Different genres are popular in different periods of time. The resurgence of genres is often considered to be revisionist and the content changes in relation to the age in which it is released. For example, with the Western, consider the differences between *Shane* (1953), *Unforgiven* (1992), *The Quick and the Dead* (1995) and *Brokeback Mountain* (2005).

Hybrid genres

Hybrid genres have developed alongside film history. Hybrid genres have become the norm as audiences have become more familiar with the language of genre. One example is the Horror/Science Fiction of *Alien*. *Brazil* pushes this to the extreme. This film represents the embedding of a range of visual clues (signifiers) of genre. It is a useful exercise to go through the film and note what these are. This collage of references seeks to dislocate the audience – an aspect which is central to the film. Ask yourself; when is it set and where is it set?

Form

Form is in some ways the most complicated aspect of film language. It is overarching and can sit alongside your generic convention. Is your film a comedy or a tragedy? Is it realist or fantasy? Whichever form and genre you use, it is because it is the best way to tell your story.

**Cupid of Ovid
(dir: Danny Brierley 2004)**

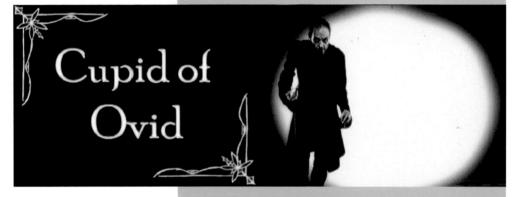

This superb short film borrows from German Expressionism in form and Ancient Greek myth in narrative to tell a contemporary story. The form is essential to the narrative content: form and content should always relate.

Writing titles

Titles can help sell a film and attract interest, so they matter. But titles don't matter enough to hold up writing the first draft. It is fine to come up with a working title and think about the problem later.

Sometimes you will get attached to a working title, and titles don't always have to be ornate. Martin Scorsese, for instance, often gives very plain titles to his films: *Gangs of New York* (2002), *Taxi Driver* (1976) and *Casino* (1995).

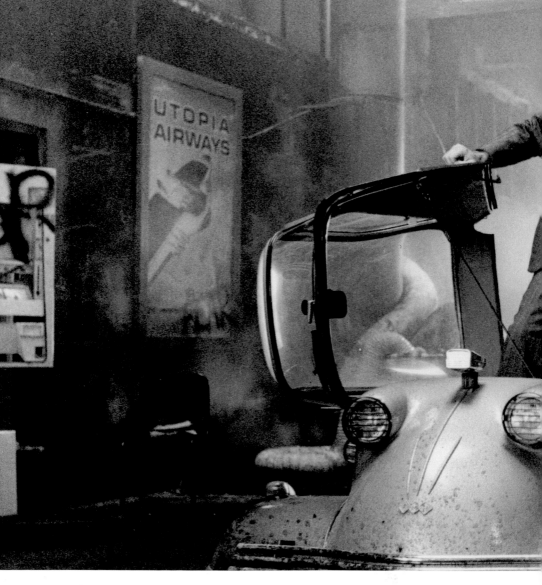

**Brazil
(dir: Terry Gilliam 1985)**

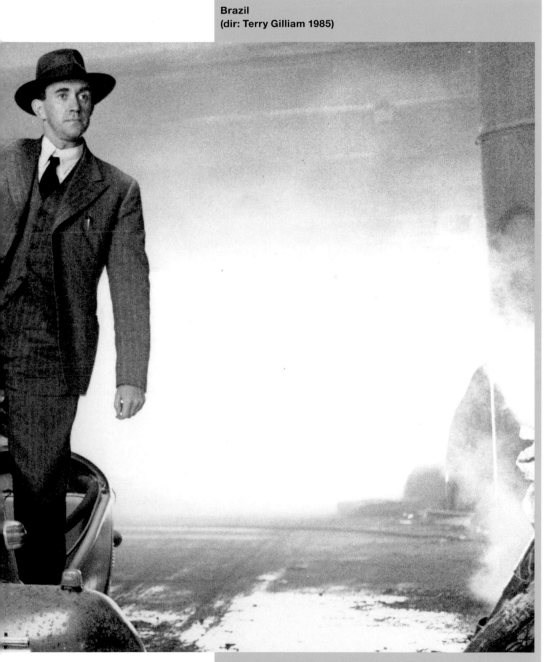

A Science Fiction/Film Noir/Soviet Socialist Realist/Manga/
Romance/Action/Thriller kinda movie based on Orwell's *1984*.
Simple really.

Glossary

Log line: a short summary of the narrative of the script, in most cases intended to sell the idea.

Once you've got the initial structure right, it's about selling and communicating your ideas to others. The **log line** is the start of this process. You have had the idea, you've thought about the context and the form. Now you need to summarise all that information for others.

A log line is the primary method of communicating and selling your idea. It is normally a one or two sentence description that summarises your story. Try to keep a log line to no more than 25 words.

When *Star Trek* was pitched as 'Wagon Train to the Stars', it served a number of functions. At the time, film Science Fiction was established but dominant. On television it was little seen. This left Gene Roddenberry with a problem – how to get across what the series would be about and how to sell it to the people with the money. This innovative log line references many of the rules of writing. It's short and to the point. It deals with form – it's a Sci-Fi programme. It relates to another genre – the Western. *Wagon Train* was one of the most popular series of the period. In referencing this, there was no doubt about the form of the programme and that it would be popular. It didn't disappoint.

You should be able to use your log line as the opening gambit in conversation or in your pitch. This is the first thing a producer or reader will see and as such needs to grab their attention. Look at the log line for *A Nice Cup of Tea* below to see how it might be written.

Writing an effective log line

```
Tea was all that kept Keith going. He'd often say he could murder for a
decent cup of tea. People laughed, but he meant it.
```

An effective log line should aim to communicate five key points. The log line for our sample script, *A Nice Cup of Tea:*

- Introduces the main protagonist – Keith
- Introduces the theme – tea
- Provides the main plot device – murder
- Suggests the genre and form – comedy/thriller
- Hints at, but doesn't reveal, the ending – does he kill for tea or not?

Star Trek
(US TV series, 1966-1969)

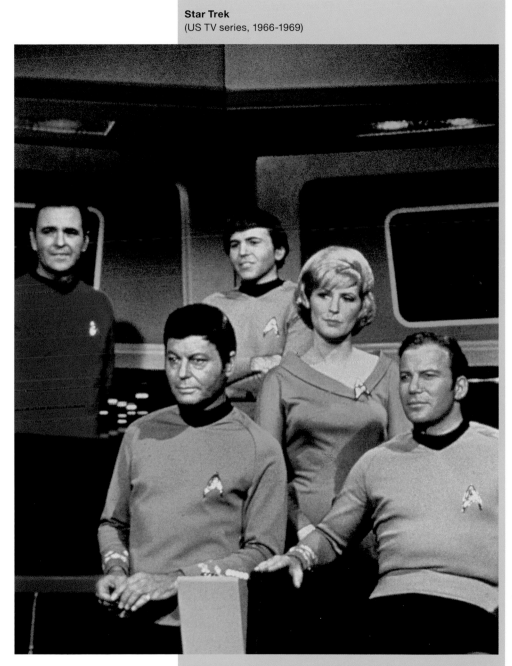

When first pitched to an executive, *Star Trek* was referred to as 'Wagon Train to the Stars'. An early example of a log line being used in a pitch.

Glossary

Treatment: a short prose summary of the script idea normally intended to gain interest and to sell.

Character motivation: the rationale for character behaviour. This is normally logical behavioural traits.

Film **treatments** vary by the nature of the person or organisation to which you are submitting, and you should always check the specific submission regulations. If you are required to send a treatment with a script, then ensure that you include a title page (as indicated in the section below on script formats).

Keep it as short as possible. Your treatment may only be two pages and your script 16 pages, but this is still asking for an investment of 60 plus minutes from a producer who will undoubtedly have many submissions. A single – or two – page treatment is more likely to grab the reader's attention.

The basic function of a treatment is again to summarise, communicate and sell your idea. Normally they are constructed in the form of prose and are akin to a short story containing the main story elements, characters and an indication of style. They communicate the spine of the story.

Tips for writing a successful treatment

- Start with a strong opening. Beginnings are important and your title is the first point of communication.

- Causality is crucial; relate the events to each other so you show narrative progression rather than a simple story.

- Introduce your main characters at the point we meet them in the story.

- Provide an indication of **character motivation**, but don't worry about the minutiae of a character's life – only include that which is essential.

- The ending is equally important and should be equally strong. You may want to withhold the ending to tempt a producer to read the script. This is a safer bet with shorts rather than features where a greater outlay in reading time is required.

- If you have to submit a treatment without a script and the guidelines allow for it, you should allow yourself a little more room – you may even wish to include a sample section of script. In this instance, you should indicate the ending and consider using the end of the script to do this.

The treatment – an example

A Nice Cup of Tea - Treatment

'A Nice Cup of Tea' tells the story of Keith Underwood, an insurance clerk, whose only pleasure, only relaxation, only escape from the world is the very English solace of a nice cup of tea. On the day on which the film is set, Keith fails to get his cup of tea. Terrible consequences follow.

Keith is in his late thirties and is married to Christine, who despises him. They have two children, Jacqueline (13) and James (11), who ignore him. Christine is having an affair with the next door neighbour, Richard. Keith doesn't know this - but he's about to find out

Keith lives in an unexciting and unattractive outer London suburb. He's a clerk for a large insurance company. He's overworked and underpaid. His boss despises him and bullies him. The only thing that lights his darkness is Denise, the tea lady. Not only does she bring the life giving tea, she's also rather attractive. Keith thinks she likes him. Denise is having an affair with Keith's boss. Keith doesn't know this - but he's about to find out

Keith's often thinks his life is not worth living, that he'd be better off dead. He's probably right, but since this is a very black comedy he gets there in a roundabout way.

'A Nice Cup of Tea' is set in the 1950s. It will be filmed in black and white though it is possible that the final scene will be filmed in colour. The aim will be to make it look as 'English' as possible in the style of the Harry Enfield 'Mr Cholmondeley-Warner' spoofs

The film will use as little dialogue as possible and will not be longer than ten minutes. It will be filmed mainly on location.

The film never shifts from Keith's point of view. It is his story and begins when he comes down to breakfast. We are introduced to Christine and the children. They have eaten all the bacon and cereals. Keith can cope as long as there's tea - but it's hopelessly weak and lukewarm. Then he finds he's running late

On the way to the station he passes his neighbour Richard, who we'll meet later. At the station, the service is too slow at the café for him to get a tea before his train comes. The train itself is too packed for him to make it to the buffet car.

At work he almost gets a cup at tea break but before he can drink it he is summoned by his tyrannical boss and sent out to see a client. The client, an old lady with a house full of incontinent cats, offers him a cup of tea but it is so disgusting he can't drink it.

When he arrives back at the office he's just too late to get a lunchtime cup from the canteen. He has a terrible headache as is counting the minutes until the afternoon break. When the tea lady arrives she is diverted into the boss' office - for a long time. When Keith can stand it no more he storms in, catches them having sex and throws a cup of tea over them.

Armed with his redundancy money Keith calls in at an expensive café on his way to the station. He is about to be poured the perfect cup of tea when there's a power cut. In the darkness the waiter spills the tea all over Keith.

On the train on the way home, Keith nearly gets a cup from the buffet car. But just as the steward tips the teapot a man collapses with a heart attack and the steward abandons his post to help. Desperate, Keith pours himself a cup. Then someone pulls the communication cord.

Dying of thirst Keith arrives home very early with a pounding head. He makes himself a cup of tea and goes upstairs to lie on his bed and drink it. When he arrives in the bedroom he finds Christine in bed with Richard. Shocked, he drops the cup of tea. The screen cuts to white

The next scene is ethereal. Keith is sitting somewhere white. A figure who looks like a butler is serving him the perfect cup of tea. Keith drinks it. For the first time in the film, Keith looks happy. But everything isn't as it seems - the explanation is in the script

This treatment is for the script that follows in future chapters. It is instructional, it tells the story and gives the reader an indication of how the film may look without being too directive. Remember that with a treatment you are selling a film, not presenting a piece of prose fiction.

Glossary

Step treatment/step outline: a more detailed form of the treatment that breaks down the structure and causal relationships of the story idea.

The **step treatment** (also referred to as the step outline) is a useful document. Some writers start with a step breakdown of a story and then return to it once a treatment has been written.

This can be dangerous, as it can limit your imagination and force you to try and structure too early. Conversely, it can save you a great deal of time working on a story that has no future. Establishing whether a step treatment should come before or after your log line and treatment is a matter of personal choice that comes from trial and error and relates to the specific script you are working on.

It is a breakdown of the essential elements of the story; provide a couple of lines for each – detailing actions, characters and settings.

It is often helpful to buy a pack of filing cards and write the brief details of each individual scene on a card. Then you can lay them out and, if necessary, move them round. It is usually much easier to alter the structure of a short using this method than it is to attempt it once the script has been written. In this way, you can *see* the story – and be honest about the potential of your story.

Reviewing your step treatment

Look back at the rules in Chapter 1: What is a screenplay? If you find you are running over many pages and jumping between locations, perhaps your idea requires revision and isn't suitable for a short as it stands. This process can save you a great deal of time over the writer who launches straight into a script.

**Stalled Juncture
(dir: Mark Preston 2005)**

Examine these stills from the short film, *Stalled Juncture*. A step treatment would indicate the key elements of the story and link them – providing an overall narrative and the skeleton of the story. Without dialogue and music, the images lack the emotional impact the film has, but you can still tell the story. What would *your* step outline for this film look like from these images?

Okay, so you are convinced your story works. You have worked through the processes; you have a log line, a treatment, character biographies and maybe a step treatment. Now you have to convince others it's a good idea. This is where the **pitch** comes in.

In low budget film-making, it is more than likely that you will have to pitch your idea in front of your peers or a funding agent. This can be done as a one-to-one or in front of a panel or potential crew. However, many festivals will expect you to pitch in front of an audience, some of whom may be your competitors.

Many people prefer to pitch with examples – video clips, photographs, graphics and even occasionally a specially shot **teaser trailer**. While this can be useful, you should always check whether you can use these. Be prepared to pitch on your own as one person in the spotlight. This is often the most effective method of selling your story – it is the idea that you are selling, not your computer or editing skills.

The challenge of screenwriting is to say much in little and then take half of that little out and still preserve an effect of leisure and natural movement.

Raymond Chandler

Preparing for and delivering the pitch

Any form of pitch preparation is crucial and falls into four main areas:

What is popular with the people you are pitching to?

Ask yourself the following: what other work have they produced? What length of film? What are they looking for at the moment? But be careful – you still need to be yourself and show that your idea has integrity.

How long do you have?

Stick to the time you have available. This will vary in each different environment – even when you are pitching the same story. Under-running (while still getting your story across) is better than running out of time. Sometimes you will be told that there is, for example, 10 minutes plus five minutes for questions and answers. If not, then allow for and invite questions. Be prepared for a grilling – you need to know all the answers. Getting flustered or lost at this stage is fatal.

Getting the important aspects across.

You know the story; make sure others get the relevant and important detail. One way of testing how much detail is enough is to look at character biographies – how much you need to know versus how much your audience needs to know. Balance your pitch – devote time to the important plot details. Never, ever withhold the ending, even if it has a twist.

Being true to yourself.

You are selling an idea, but you are also selling yourself. Never try to make yourself something you are not; a façade will crumble very quickly. You are selling a person who has integrity and will deliver a great script. Buying a floppy hat and a cravat will not make you a great writer or even give you the appearance of one. That is down to the preparation identified above.

You are now ready to deliver your pitch. Practise in front of others. Sell your idea to others; it is harder to pitch to friends than it is to producers, commissioning editors or funders. Nerves are understandable, particularly as a new writer; but have confidence in your idea – that is essentially what people are there to hear. And remember: everyone is in the same boat.

Glossary

Pitch: the (normally) verbal presentation of the story concept given in order to gather interest either for development funding or to sell the idea.

Teaser trailer: the term applied to a short trailer that is used to sell a film in advance of a main advertising trailer closer to release. It is also applied to a trailer that is created to sell a concept – to show what a film might look like if given funding.

You are now getting ready to write, but why the importance of a section on formatting your script? The answer is a simple one. If you don't format your script in the industry standard way nobody will pick it up. Conventions have developed over time and everybody involved in film production will expect these conventions to be met and will require them to make their job easier. It isn't just about the look – it's about legibility.

Basic rules of formatting

- The font is *always* Courier.
- The title page should have the title of the film in capitals and your name underneath. Your name and full contact details should be in the bottom right hand corner (or that of your agent in the future).
- You are writing action; the script is driven by the actions of characters in specific locations, with dialogue embedded within.
- Scene headings are written in capital letters and aligned to the left. Abbreviations are always used, for example: INT. (interior), EXT. (exterior). This is followed with the location (follow with a hyphen, then the location). You may wish to add the time of day following this.
- Leave two lines and move to description which should be justified across the page.
- Character names should always be capitalised in dialogue and in description when they are introduced for the first time. Dialogue should be centred and run under the character's name.
- If you want to give an indication of how a character should deliver a line, place it in brackets under their character name.
- The (CONT'D) is there is to indicate that the sound cuts across the speech. The sound is capitalised as it forms a sound cue. The CUT TO indicates the break to another scene. This is another abbreviation and normally consists of CUT, FADE or DISSOLVE – but these notes are not essential. The presence of INT. or EXT. at the top is enough of a clue that the scene has changed for the director.

Read the following fragment of script on page 59 to gain a sense of how formatting rules should be applied to a working script. Then practise using them by writing the next scene.

```
INT. WRITER'S LIVING ROOM - NIGHT

The living room is sparsely decorated with only the glow of an ancient
laptop to illuminate BOB's face.

JIM and YOHAN sit shrouded in darkness on a dilapidated couch.

Bob types frantically for a moment. Stops dramatically, pauses and hits
the delete key.

                              BOB
                           (Angrily)
               I can't think of anything to write.

                             YOHAN
                           (Resigned)
                        None of us can.

                              JIM
                      Listen, if we just

SCREAMS echo from outside the room

                              JIM
                Started to … what the? (CONT'D)

                                                        CUT TO
```

> Whenever you write, whatever you write, never make the mistake
> of assuming the audience is any less intelligent than you are.
>
> Rod Serling

A note on adaptation

Adaptation accounts for the majority of feature films produced. There are a number of reasons for this; the main being that a pre-existing novel has a track record. It is also easier to pitch a pre-existing narrative. Optioning a novel is also pretty cheap in feature film terms.

Adaptation is rare in short film. The content is difficult to cram into the short film format. Optioning a novel is very expensive in short films.

Adaptation is a very useful exercise when developing your skills as a screenwriter. A lot can be said by a narrator in a book. You are told – in film you are shown.

Screenwriting resources

There are many resources available for screenwriters, including:

Script format examples :
www.bbc.co.uk/writersroom/insight/scriptsmart_formats.shtml

Downloadable script formatting software:
www.practicalscriptwriter.co.uk/download.asp
www.bbc.co.uk/writersroom/scriptsmart/
(Script Smart templates for Word)
www.celtx.com/
(freeware that includes project management software)

Software for purchase:
www.finaldraft.com/ (PC and Mac)
www.screenplay.com/ (PC)
www.marinersoftware.com (Mac)

Microsoft also provide a downloadable template for Word 97 and after:
www.microsoft.com

www.openoffice.org has free downloadable templates from a number of developers – it's free and works on MS, Mac OSX, Linux and Solaris systems. There's no longer any excuse to get the formatting wrong!

Of course, you could always create your own to match the brief. Examples of a script formatted in the correct way can be seen throughout chapters three and four.

Read professional screenplays – this is the best way of perfecting the appropriate style.

The importance of script formats

The rules of scriptwriting are important. If you fail to follow an established format, your script will not be read. Always follow the rules that are set by the industry.

If you are intending to send your script to an agent or producer, then ensure that you check their specific guidelines.

Many scripts are never seen for failing to adopt this simple rule.

EXERCISES

As you are developing your ideas try the following exercises:

Take a film (script and/or finished film) and write your own trailer for it. What aspects of the story would you identify as useful in summarising and selling the story?

Take any newspaper story and pitch it as a story to someone else. How would you go about making it interesting?

Take any newspaper story and summarise it as a log line.

Ask a friend to read out the summary of a film from the back of the DVD box, without any reference to the title or main actors. What film are they describing?

Observe four people in four different real-life situations. Write their character biographies. What scenarios could you create for them to meet each other?

Take the opening pages of a novel and attempt the process of adaptation. How do you deal with the detailed description? What do you keep: what do you reject? How do you introduce your main characters? You are being told a lot – what do you show? You may leap in time period but how do you do this without confusing your audience? How quickly are you tempted to add a voice-over?

FIRST DRAFT

**The Spy Who Loved Me
(dir: Lewis Gilbert 1977)**

What is the Bond villain's downfall? They break the golden rule of how to successfully dispense with your nemesis. This is also the golden rule of screenwriting – keep it simple.

The patron saint of writers is St Francis de Sales, but it should really be William of Occam, a fourteenth-century Franciscan friar and philosopher. He is known for the phrase *'Pluralitas non est ponenda sine necessitate'* which can be translated as: plurality should not be posited without necessity.

This saying is known as Occam's Razor and suggests that you shouldn't make things more complicated than you need to. Faced with a lot of explanations, go for the simplest. This is also known as the James Bond villain conundrum. It is always in their best interests to skip the gloating and shoot Bond in the head immediately, but none of them ever thinks of this.

Occam's Razor should be kept in mind at every stage of the first draft: keep it simple!

On the pages throughout this chapter you will see examples of draft one of a script – *A Nice Cup of Tea* – with key questions provided. This script is intentionally flawed, but it does relate to many of the questions that will present themselves to you when you are writing your first draft. The script and the questions can be read in their own right or in conjunction with each other.

The script is also reproduced in the Appendix as a complete document – so read it there too in order to compare it to the second and final drafts that you will encounter later in the book, and track the changes that we have made to it. Decide for yourself whether we made the right editing choices!

Character is fundamental to screenwriting. Asking what comes first – story or character – is a chicken-and-egg question. The two cannot be disentangled. A film, short or feature is always about a person or persons who perform a series of actions. Without character, there is no story.

Creating characters

For your film to succeed, you need to know your characters in depth. You need to know what they think, what they feel, what they want, what they need. Sometimes you need to know them better than you know your friends. You do not always know exactly how they will react. Good characters have enough reality built into them to make them as unpredictable as real people. The study of these signs in film (or in life) is called semiotics.

In real life, the moment we encounter someone new we start sizing them up. Our primary impressions are visual: are they attractive? Threatening? Friendly? We start noticing the way they speak, their accent, their manner of addressing us. We weigh up their mannerisms, how they react to other people – and to us. And, of course, we listen to what they're saying.

We assemble these impressions very quickly and make an instant judgement. Later we may change or modify this judgement. This process is mirrored in films – but feature films have the luxury of time in which to explore the characters. Shorts don't. Even if you spend the whole of your film developing and revealing a character, you will still have less time than a feature film spends on the first act.

You sell a screenplay like you sell a car. If somebody drives it off a cliff, that's it.

Rita Mae Brown

Key character questions

There are some essential questions that should be considered when creating characters.

Who are they?

First, what do they look like? A description of the character's physical appearance is worth spending time over. The way we look affects the way other people react to us. If your story is about a woman's search for romance/true love, the way she looks may well have a bearing on how the story develops.

More important, however, is the character's psychology: what is their view of life? What do they think and feel? Are they cheerful and optimistic? Cynical? Depressive? Do they thrive on stress or roll themselves up into a ball?

These questions must be answered before you can decide how they will react to a situation and how they will react to other characters too.

What do characters want? (part one)

Another way of framing this question is to ask: what is driving the character through the story? What do they want to achieve? In *Jaws*, it is easy to see what Chief Brodie wants – he wants to destroy the shark. In *Bridget Jones's Diary*, Bridget wants a boyfriend. In *Shrek* (2001), Shrek wants everyone to leave his swamp and leave him in peace.

This is sometimes called the character's outer motivation – it is the obvious reason for their actions.

Characters in short films

In short films, you have to establish your characters quickly and efficiently. You also have to keep the numbers down. It is often tempting to add characters, but you must be ruthless. Ask yourself if a character is strictly necessary. A lot of films manage with two or even only one character.

A Nice Cup of Tea has a lot of cameos, but it is focused on only one character. The rule with characters is: if in doubt, cut them out. Creating characters is hard work, but it is one of the more enjoyable parts of the writing process. It is essentially a process of asking questions – just as we do in real life.

INT. KITCHEN. HOUSE. DAY.

It's cramped and rather shabby. Two CHILDREN, JAMES aged 11 and DENISE aged 9, sit at a square table. CHRISTINE stands by the sink washing up in a desultory fashion. She's in her mid thirties. She doesn't look very happy.

Enter KEITH UNDERWOOD. He's late thirties, harassed looking. He's obviously running late and he isn't very happy either, but fixes a smile on his face.

> KEITH
> Good morning all.

They all ignore him. Keith goes to a work surface. There is a teapot under a tea cosy. He looks at the plates in the sink.

> KEITH
> Breakfast?

> CHRISTINE
> We're out of bacon. The kids had the last of the cornflakes.

She is daring him to fight back. He controls himself.

> KEITH
> Right. Fine, I'll just have a nice cup of tea.

He takes the tea cosy off the pot. Finds a cup and saucer.

> KEITH
> Tea. That's all I need to set me up for the day.

He lifts the tea cosy, touches the pot, and yes - it's hot. He adjusts the cup and saucer, puts the strainer in place and slowly tips the pot. The tea is hopelessly weak, the colour of peat bog water. His face falls.

> KEITH
> For Christ's sake…

> CHRISTINE
> Language.

> KEITH
> You've only put in one spoonful of tea. Why do you always do that?

They talk across each other. This is an old argument.

A Nice Cup of Tea - 1st draft, continues P.71

What do characters want? (part two)

Many of the things that drive us, that cause us to act in the way we do, are hidden from the outside world. We usually don't admit that we are doing something because we are jealous, or angry, or frightened – even to ourselves. Yet these are very powerful motivators and creating characters with depth means that the writer has to know about their inner lives.

This is sometimes known as a character's inner motivation. Very often, the character is trying to overcome some inner handicap or inhibition, to exorcise some inner demon. In *The Silence of the Lambs* (1991), Clarice is trying to track down Buffalo Bill in order to stop him killing, which is her outer motivation. But her inner motivation stems from a childhood memory – of the fact that she was unable to stop lambs being slaughtered.

In *Jaws*, Chief Brodie is frightened of the sea, so he must overcome this fear in order to achieve his outer goal – of saving the townspeople from the shark.

What do characters want? (part three)

Just to complicate matters, there is the question of people who want or need something but won't admit it. In *Groundhog Day* (1993), Phil needs love but, at the beginning of the film, is unaware of this. The same is true of *Shrek*; he thinks he wants peace and quiet and solitude, but finds that what he really needs is love.

Sometimes the hidden motivation is that the character needs to be true to his or herself. In the film *In & Out* (1997), Kevin Kline realises he's gay. Many films are built on the premise that, in the course of the story, the character discovers his or herself.

How do characters get what they want?

What actions do they take to achieve their end? Do they use cunning? Do they get violent? Do they deal with a problem by confronting it head on, or do they run away? The way in which a person reacts to events reveals their character.

Glossary

Character biography: a device often used by writers to outline the back story of a character. Sometimes used by directors when working with actors.

Action is character

Though we can learn a lot about a person through listening to what they say and how they say it, it is the way in which a person behaves that reveals their true nature – in movies and in reality. Someone may boast about their strength and courage, but if they run away when danger threatens, this is usually a fair indication that they are ultimately a coward.

Why do characters behave like that?

Or, alternatively, what made them the way they are? This is sometimes called the **character's back story or biography**. Many factors go into building a character – real or fictional. What were their parents like? Were they rich or poor? How many siblings do they have? Where did they go to school? What did they want to be when they were a child? Who was their first true love?

The more questions like this that you can ask – and answer – the better you will know your character and the more real they will be. For major characters, you need to write a fairly comprehensive biography. This takes time and thought, but once you have done it you will be able to answer the question: who are they?

Names

Names matter – they can be used to tell us things about the character. In the martial arts classic *The Way of the Dragon* (1972), Chuck Norris's character is called Colt, making us think both of the young male horse and of the gun – both symbols of American masculinity.

It can be a bad idea to spend too much time on finding appropriate names for characters. They can always be christened with a provisional or temporary name and renamed later.

Character biography

If you're stuck with a character biography and your character has a job, try writing the CV that got the character the job. Or try writing their annual appraisal report. Think how they would react if they were real people.

Let's face it. If, as an audience, we didn't believe that the characters on screen were in some way real, the whole act of watching a film would be pointless.

**Sexy Beast
(dir: Jonathan Glazer 2001)**

In *Sexy Beast*, Gal's inner need is for peace and the love of his wife
– his outer goal is to get the psychopathic Don Logan out of his life.
Sometimes a character's inner motivation is openly on show: at other
times it is hidden. It can be very clear and straightforward – like a
need for revenge, or it can be far vaguer – such as the character
wanting peace of mind.

A screenplay creates a world. It may be identical to the real world (except that it contains fictional characters) or it may be wildly different. Whatever world is being created, it must be internally consistent. It must have rules and those rules must be adhered to, otherwise the story will lack logic and the audience will become confused. Confused audiences usually stop watching.

Groundhog Day (1993) is a good example. The day only repeats itself for Phil Connors (Bill Murray); as far as everyone else is concerned, everything is completely normal and all the usual physical rules of the universe apply – snow is cold, water is wet etc. The film works because the writer has, very skilfully, woven Phil Connors's unreal story into a real-life normal day.

The short French film *The Nail Clippers* (1969) is also set in a recognisably real world, except that a series of objects, beginning with a pair of nail clippers and ending with guests, vanish from a hotel room. And, as in *Groundhog Day*, no explanation is ever given for what's happening. Audiences don't need, or even want explanations as long as they can follow the logic of the action.

It is, therefore, important to spend time on making sure your fictional world is internally consistent – especially if you are writing anything fantastic or supernatural. If, for example, you're writing a ghost story, ask yourself questions like: does it haunt a place or a person? Can it affect the physical world? Does it exist or is it all in the mind?

Supernatural, realistic, fantastic – remember William of Occam: keep it as simple as possible.

Though it's important to spend time on creating the world, it's also important not to spend too much time. Tolkien obviously had a great deal of fun creating all the artefacts of Middle Earth – the maps and the languages – but he also got round to writing the story. Once you have the basic rules in place, don't delay: begin writing.

Being a real writer means being able to do the work on a bad day.

Norman Mailer

 CHRISTINE
 You're the only one that drinks tea...
 KEITH
 One spoonful for each person and one for
 the pot...

 CHRISTINE
 ...and you never drink more than one cup

 KEITH
 ...freshly boiled water, and let it stand
 for five minutes. Is that so hard?

 CHRISTINE
 It's a waste.

 KEITH
 Tea's cheap. We can afford tea.

 CHRISTINE
 On what you bring home we can't
 afford anything.

 KEITH
 Except bingo...oh, and cinema tickets.

He grabs at the pot and flings its contents into the sink.

 KEITH
 I'll make it myself.

Then he starts looking for the tea, opening cupboards. Christine stands
back, arms folded. James and Denise look faintly bored. Keith is about to
crack and ask Christine where it is. But he sees the kitchen clock. It says
twenty past eight.

Keith looks at his cheap looking watch. It says five past eight. He taps
it. It's stopped. This is very bad news.

Christine looks at her watch. It's much nicer than Keith's. Smiles.

 CHRISTINE
 I make it twenty past, too.
 (a beat)
 What time's your train?

Glossary

Mise en scène: translates to mean 'within the frame' and describes everything that can be seen on the screen.

Sight is our primary sense. Our first impressions of things and people are mostly visual. This is reflected in our language. We talk of love at first *sight*; we say we don't like the *look* of something; we ask why someone can't *see* we're right. Film is a visual medium. Modern cinema grew out of silent movies and film should always aim to tell a story in pictures.

The screenwriter should always be thinking of ways of using the physical setting, the *mise en scène*, to convey things to the audience. Look at either one of the three drafts of *A Nice Cup of Tea*, in this chapter, or in chapters 4 and 5, and you will note how objects and settings are used to convey meaning. The kitchen is cramped, the fittings shabby, Keith has a cheap watch, his suit is old. The only new object is his wife's watch.

Mise en scène and dialogue

As a general rule, the screenwriter should treat dialogue as an extra; something to be used only when the pictures have done everything they can to tell the story. Dialogue shouldn't be used to point out something the viewer can see for themselves. Look at the opening scenes of *Se7en* (1995), for example.

A note on effective description

There is no need to overdo description, but it is important to make your *mise en scène* work for you. If it is well written, it helps the reader of your script see what the finished film will look like. A script is a set of instructions and *mise en scène* tells the set designer and the director how you envisage the setting of the action will take place.

Symbols and symbolism

There is a temptation for short film-makers to go over the top with symbolism. Used properly, symbols can add meaning and depth to a film. In *The Godfather* (1972), oranges are the symbol of death and appear whenever a death or assassination attempt is about to happen. In *Chinatown* (1974), which is about a conspiracy involving water, there is a great deal of symbolism involving water.

However, it is possible to be too heavy handed with symbolism. Usually, audiences won't notice the symbolism on a first viewing unless they're watching for it. Try to consider symbolism as a powerful seasoning: used sparingly it can add flavour and bite; overuse it and it will overwhelm all the other ingredients.

Se7en
(dir: David Fincher 1995)

Morgan Freeman's character, Somerset, believes in order. In his apartment, his chess set symbolises the battle between good and evil and he sets a metronome before going to sleep; this order contrasts vividly with the chaos found in the killer's house. It also tells us a great deal about his character and cuts the need for self-explanatory dialogue. His character throughout the film sticks to this initial set-up, and Brad Pitt, as Mills, acts as a perfect foil or contrast. They are binary opposites who together make up the whole.

EXT. HOUSE. STREET. DAY.

It's raining hard. As Keith hurries down the drive, he passes his neighbour **RICHARD**. He's about the same age but far more self assured; he's also tall, handsome and owns a car.

He's opening the driver's side door. He has an impressive-looking vacuum flask under his arm.

> RICHARD
> (complacent)
> Horrible weather.

> KEITH
> Yes. Can't stop. Train.

> RICHARD
> Trains? Never again. Want to get yourself one of these

He grins. Keith scurries off into the rain.

EXT. RAILWAY STATION. DAY.

There's a small hatch behind which a **WOMAN** is serving drinks. It's crowded. Keith has one person in front of him. The tannoy crackles. It's echoey and largely incomprehensible.

> TANNOY
> Mumble...8.31...mumble...now...mumble... platform two...

The woman is pouring tea from a huge metal teapot. She serves the **MAN** at the head of the queue. He's very slow in finding change. Keith is almost dancing with frustration. A train pulls in. We hear the doors opening. The Man is still fumbling with his change. Finally he pays. Keith makes it to the counter.

> KEITH
> Tea please.

The Woman tips the teapot. Keith turns briefly to see the commuters boarding the train. Come on. Come on. The teapot tips further and further – now the spout is pointing straight down. But it's empty. The Woman grimaces. Keith is devastated. He turns and runs for the train.

INT. TRAIN. CARRIAGE. DAY.

It's packed, almost too crowded to move. Keith is wedged in near to the doorway between two carriages. If he stands on tiptoe he can just see the buffet car. But he can't get to it; he struggles a little but it's no use. He's not going to make it – it will remain out of reach.

INT. FOYER. OFFICE BUILDING. DAY.

It's four minutes past nine. The foyer possesses that quality of echoing emptiness that always makes the late arrival feel highly conspicuous. Two RECEPTIONISTS look at him with a mix of pity and interest, like watching a condemned man on his way to the gallows.

A Nice Cup of Tea – 1st draft, continues page 75

INT. OFFICE. DAY.

There are two rows of desks. All occupied, bar one. Keith enters, several people look up. His eyes flit to a glassed off Inner Office. He sees the door's shut. Looks relieved. Hurries across the unoccupied desk. Sits, snatches papers from his in-tray.

DISSOLVE TO LATER

The pile of papers in the in-tray has diminished. The pile in the out-tray has increased. The clock is ticking towards 10.45. Keith massages his temples, winces and then rubs sore eyes. He looks at the clock longingly. The minute hand touches the nine.

The door opens. A **TEA LADY** enters, pushing a tea trolley. The tea lady, Denise, is friendly, slightly plump and not unattractive.

Keith's desk is nearest the door. She comes to him first.

 KEITH
 Denise, even if that pot was empty, you'd
 still be the best part of my morning.

 DENISE
 It is empty.

 KEITH
 I don't care.
 (a beat)
 It's not...

 DENISE
 Of course not.

She lifts the teapot.

 DENISE
 Freshly boiled water, warm the pot, brew for
 five minutes, tea in first.

She pours the tea, picks up the milk jug. The cup is filled. She places it on a saucer and hands it to him. He stares at it, catches the aroma and is about to drink when...

The door of the Inner Office swings open. **HARRIS**, Keith's boss, stands in the doorway. He's big, handsome, about forty. Alpha Male. He bellows:

 HARRIS
 Underwood! In here. Now!

Keith hesitates for a second. Looking at the tea.

 HARRIS
 Leave that! I said now!

Defeated, he puts his cup on the desk.

A Nice Cup of Tea – 1st draft, continues page 77

Character motivation

The way in which a character behaves and the actions that they carry out can tell us much about their motivation. In the short film *The Nail Clippers*, the central character demonstrates the nature of his personality – slightly obsessive, fussy and controlling – by the manner in which he inspects the facilities in his hotel room.

In the scene below, a couple are conducting an illicit affair in a borrowed flat. Obviously, one can add dialogue to add depth to the characterisation, but the actions detailed here should tell the viewer a fair amount about the state of the relationship. You could read this scene as suggesting that she wants more out of it than he's prepared or able to give. You might also think that she's less bothered about anyone finding out than him – she seems to be happy to stand at the window naked. What else might you infer from the following script fragment and what might the characters do next?

```
INT. FLAT. BEDROOM. DAY.

A man and a woman are lying on the bed, half covered by a sheet. The woman
sits up and puts her feet on the floor. As she stands he reaches for her -
but she shakes him off.

Completely naked, she walks across to the window which is uncurtained and
hasn't been cleaned for some time. She stands at the window looking out over
the street. She moves closer, breathes on the glass as David gets up from
the bed with a sheet draped over his shoulders.

She draws a heart with her finger on the misted glass. She writes 'Eve 4
Adam' in the heart. He comes up behind her and wraps the sheet round both of
them. She cranes back to kiss him. Then she looks at his left hand, touches
his wedding ring. He sighs.
```

INT. INNER OFFICE. DAY.

We are looking down from a high corner. Keith sits huddled in on himself, like prey, as Harris circles, verbally battering him and drinking a cup of tea. We hear the slurping as he drinks his tea. He picks up a sheaf of papers, stapled together, with his free hand.

> HARRIS
> Sloppiness, Underwood, sloppiness up with
> which I will not put.

He drinks some tea. Keith's eyes follow every movement, longingly.

> HARRIS
> Just like lateness. I don't put up with
> lateness. So someone who is late and sloppy
> had better hope I never find out. But of
> course I do find out. Always.

Keith raises his head a fraction.

> KEITH
> But Mr. Harris...

> HARRIS
> Do not interrupt me. You know what this is?

He places the paper on the desk in front of Keith, takes out a pen and writes three letters - N.B.G, large and bold. As he does so, Keith can smell the tea, can see it only a few inches from his mouth - but it's utterly unobtainable.

> HARRIS
> It's three letters - N.B.G. No bloody good.
> Not acceptable. And do you know what you're
> going to do about it? I'll tell you. You're
> going to do a home visit. Now.

> KEITH
> Now?

> HARRIS
> Yes. As in get out of my office, put on your
> coat and go. Now.

EXT. OFFICE BLOCK. DAY

The main entrance. Keith hurries in looking even more weary.

INT. OFFICE BLOCK. FOYER. DAY

The big clock reads three minutes to two. The lift doors are open as Keith hares across the foyer to the lift. The doors shut just as he reaches them. He runs for the stairs.

A nice Cup of Tea - 1st draft, continues page 78

The physical world – *mise en scène* > **Action** > Tone and genre

INT. OFFICE BLOCK. FOYER. SIXTH FLOOR. DAY

It is open and empty. There are two flights of stairs on either side of the lift shaft. Keith stumbles up the left hand one, gasping for breath. The clock on the wall above twin sets of double doors reads one minute to two. He staggers across the foyer and virtually throws himself through the left hand doors into:

INT. CANTEEN. OFFICE BLOCK. DAY

It's large and virtually deserted. About half a dozen late diners are just finishing up. The canteen is a 'collect your tray and move along' arrangement. The serving area occupies an entire wall of the canteen, with the kitchens behind. There are rails in front of it to corral the customers.

Keith pays no attention to the **KITCHEN HANDS** who are emptying and scraping the trays that contained the food. His glance goes straight to the area by the till. The hot drinks area. He dashes for the start of the rails and almost runs along as the shutters come down in an almost synchronised fashion.

Each one shuts just as he reaches that section of the serving area. Despairingly he watches as a WOMAN reaches for the shutter that will keep Keith from his goal...

> KEITH
> No!!!!

But too late. The shutter comes down. Enraged, Keith hammers on it.

> KEITH
> I only want a cup of tea.

INT. OFFICE. DAY.

Keith is working. We go in close on the clock. And see the big hand touch the twelve.

Keith puts his pen down, checks his watch. The door opens. Denise enters. Keith lets out a sigh of relief. He smiles at her. She smiles back. He's about to say something when the door of Harris' office opens.
Harris steps out.

> HARRIS
> Miss Sutton - a word.
> (a beat)
> And a tea, if you please.

Denise smiles apologetically. She pours a tea and takes it into Harris's office. The door closes. There is a general frisson of disquiet round the office - but no-one quite knows what to say.

It is as though time has frozen.

The clock is now at ten past. There is now a definite restlessness in the office.

> WORKER #1
> It'll be stewed.

A nice Cup of Tea - 1st draft, continues page 81

Making characters seem 'real'

Always remember that there should be a reason for everything your characters do, especially in a short film. Time is limited; you have to make every detail count. To give another example of how actions can tell a story, think of a character looking at their watch: if they are in the presence of someone they don't want to offend – like a boss giving a very boring speech – they will look at their watch furtively; if your character is the person in charge and wants to let someone know they're over-running, then they may make a big show of looking at their watch, even tapping it for emphasis.

If two of your characters are conducting a clandestine affair, one person might look at their watch and then at the other person to signal that it's time to steal away. All of these examples demonstrate the same thing: action reveals character. This concept will be explored further in the discussion on character.

How detailed should descriptions of action be?

In the film *Bullitt,* the description of the five-minute car chase appears in the script as: 'There now follows a car chase'. As the writer was also the director, this lack of detail didn't matter. However, a script should aim to paint a picture; to make the reader see. Therefore, descriptions of *mise en scène* or of action should include all the essential details. But there is no need to go into unnecessary detail – it will slow your script down.

The difference between necessary and unnecessary detail is down to the nature of the script and the nature of the idea. As a general rule and if, for instance, you were describing a character who had to have a scar on his face you might suggest:

A man enters wearing a dark raincoat. He bears a three-inch scar under his eye.

It might be stepping on a director's toes and a little unnecessary or over the top to write:

A man enters on the left of the screen wearing a light beige raincoat with a belt tied in the middle cutting his tall frame in half. He has a deep scar from a knife fight he had 15 years ago. The scar is three inches long; it starts just under his eye and winds its way down to the twitching corner of his evil mouth.

The physical world – *mise en scène* > **Action** > Tone and genre

The first draft is often the point at which the writer discovers that their film isn't exactly what they thought it was. A drama becomes a comedy, a comedy morphs into a thriller, a romantic comedy evolves into a tragedy. This is quite common, especially in short film. The important thing is not to panic.

Stories can shift genre with very little effort. *Groundhog Day* (1993) is a comedy, but the idea could also work as the basis for a psychological horror story. *A Nice Cup of Tea* is a black comedy, but alter a few details and it becomes a domestic tragedy. If you find that your story is turning out differently from the way you intended, this can mean that you have done a good job of creating character and narrative – that the story has taken on a life of its own. With a short film it is often worth going with the flow. The results can be surprising and rewarding. If you are writing a feature film you may not have time to do this and a rethink may be necessary.

It's more of a problem when the tone or genre of your film shifts in mid flow. Sometimes films may flip between genres for artistic reasons, but there has to be a strong central theme, a logic behind the change of tone. And that logic has to be capable of being worked out by your audience, otherwise all they are going to see is a meaningless montage. You'll discover that a script that has well worked-out characters, an internally consistent world and a strong narrative will not usually suffer from this problem.

**Groundhog Day
(dir: Harold Ramis 1993)**

In *Groundhog Day,* the idea of being trapped for all eternity without hope of escape is a terrifying notion and would provide the basis for a horror film or even a psychological thriller. However, where would it go? The plot would have to change. The repetition works as a comedy – would it work as another genre?

 WORKER #2
 Or cold.

 WORKER #3
 A word. A *word*.

Keith suddenly decides he must do something. He stands up, pushes his chair back. Walks towards Harris's office. Raises his hand to knock, thinks better of it. Then courage returns. He raps on the door. There's no answer.

 KEITH
 Mr. Harris...

He looks at the tea trolley. Raises his hand to knock again. Instead he grasps the handle and walks straight into:

INT. HARRIS' OFFICE. DAY

There is a cup of tea on the desk. But this is not the first thing Keith notices. Or us. Technically speaking, Denise and Harris aren't actually having sex, but they're as close as makes no difference. Keith is appalled.

 KEITH
 Denise!

They spring apart. Denise gasps and starts trying to make herself decent. Harris looks embarrassed but angry.

 HARRIS
 Underwood! How dare you!

But Keith is angry too. He picks up the cup of tea and flings the contents all over Harris.

INT. FOYER. OFFICE BLOCK. DAY

Keith is being escorted from the building by two uniformed **COMMISSIONAIRES**. He is clutching his briefcase and, in the other hand, a brown envelope and various bits of paper.
As he passes the reception desk, the **RECEPTIONISTS** look at him with vague sympathy. They are both drinking tea.

EXT. STREET. CITY. DAY

Keith is walking along looking somewhat dazed and at a loss. He passes a very expensive looking café with a snooty looking **MAÎTRE D'** at the door. In the road, a gang of **WORKMEN** are using a pneumatic drill. It yammers into life. Keith winces. His headache is still bad. Then he looks at the café. He opens his brown envelope. There's quite a lot of cash inside. He turns back.

EXT. CAFÉ ENTRANCE. DAY

He passes the Maître d' and, airily, flips him a coin.

A Nice Cup of Tea – 1st draft, continues page 83

Dialogue fulfils two major functions: it helps explain character and it helps explain the plot.

A vital thing to remember about dialogue is that it's an extra. Film is a visual medium that grew out of silent movies. The film-maker should always be thinking in pictures. The rule is: show, don't tell.

The Goat (dirs: Joseph 'Buster' Keaton, Malcolm St.Clair et al 1921)

Dialogue is there for the benefit of the audience – not the characters who are speaking. This simple rule is one of the most obvious but is all too often forgotten by new writers. Characters speak in relation to the audience's expectations of them, not how we ourselves speak. Look at different patterns of dialogue in different genres. Look at historical epics: how does the use of dialogue differ between them? Most importantly, look at silent cinema and how the rules it employs to 'tell' a story can and should be employed by the short film writer.

INT. CAFÉ. DAY.

It's very classy. Keith is seated towards the rear. We can still just hear the occasional staccato bursts from the pneumatic drill but that's not bothering Keith over much. He's concentrating on the little tea ceremony that is being performed in front of him. A very neatly uniformed **WAITRESS** is about to pour him tea.

This is a truly impressive tea service; the business. The cup is placed on a saucer in front of Keith. The Waitress lifts the teapot. The pneumatic drill stutters and there is a very loud **BANG.**

This is followed by a flash of blue light. All the lights go out. The Waitress screams, tips the teapot - over Keith's crotch.

Keith yells. There are cries of alarm. Then the Maître d' shouts:

 MAÎTRE D'
 Mesdames, monsieurs - I am sorry but I must
 ask you all to leave...

INT. TRAIN. DAY

This train has a small on-board buffet. It's busy, but not too crowded. There are about eight or nine customers. Keith is second in the queue. There is a **FAT MAN**, a business type, in front of him, taking a cup of tea from the **STEWARD.**

 FAT MAN
 Thank you.

 STEWARD
 (to Keith)
 Yes sir.

 KEITH
 Tea please.

 STEWARD
 Yes sir.

He lifts up the teapot to pour it. But...

The Fat Man cries out in pain and alarm, drops his tea, clutches his chest and pitches forward. Everyone is stunned, but Keith recovers first.

 STEWARD
 My God...it must be his heart.

 KEITH
 (coldly)
 Yes. You were about to pour me a cup of tea.

The Steward looks at him disbelievingly.

 STEWARD
 I'm in the St. John's ambulance.

A nice Cup of Tea - 1st draft, continues page 85

Tone and genre > Dialogue

'Realistic' dialogue

One of the best ways to annoy an experienced writer is to suggest that writing dialogue is easy, as all you have to do is listen to the way people speak. You do have to listen to other people's speech, but if you reproduce it exactly you have failed. The reason for this is simple; most people's speech is full of hesitations, repetitions and *non sequiturs*. Conversation between two or more people who know each other well will also be full of private allusions and unspoken or implicit assumptions that are not immediately obvious to anyone else.

The best analogy is to think of a CD recording of a live rock or orchestral concert. There is no way that you could stand anywhere in the hall and hear the instruments the way you do on the recording; it is artificial but sounds real.

Good dialogue writing consists of stylising everyday speech so that it sounds authentic. When we talk of dialogue being realistic we mean it's like reality, not that it's an exact copy of reality. Movies have been defined as: 'life with the boring bits taken out'. Good dialogue works in much the same way.

Dialogue and character

A bad piece of advice that's often given to writers is that you should be able to cover up the name of a character in a script and still know who is speaking. Although we all have individual ways of speaking, this advice leads to writers trying too hard; they end up attempting to individualise speech by giving characters distinctive catchphrases or regional expressions.

The truth is that groups of people who are close in age and background often share ways of speaking, phrases and slang. Speech is individualised by the fact that it reflects character. The way we speak reflects the way we are as people.

Dialogue and plot

Although one should always favour pictures over dialogue, often one must use dialogue to move the plot forward. Dialogue that helps explain plot is called 'expositional'. Expositional dialogue has to be handled with care because it is usually highly artificial and often it consists of people telling each other things they already know. In the first draft, you have to grit your teeth and allow your characters to do this. Advice on how to refine expositional dialogue is given in Chapter 4: Second draft (page 88).

He pushes open the half doorway and steps out.

 STEWARD
 Excuse me.

Immediately everyone is focused on the Steward as he starts to try to help. Everyone except Keith. He's had enough. He steps behind the counter and pours himself a tea. In a mug. It looks good. He lifts it to his lips. Just as one of the group round the stricken fatty — turns round and, on a nod from the steward, pulls the communication cord. The train brakes sharply.

The mug flies from Keith's hand. The teapot crashes to the floor.

EXT. HOUSE. STREET. DAY.

Keith walks back to his front door, he looks almost broken.

He opens the front door.

INT. KITCHEN. DAY.

Keith is writing a note. It reads:

'Home early. Terrible headache. Gone upstairs for a lie down with a nice cup of tea'.

He picks up a cup of tea.

EXT. LANDING. DAY.

Keith looks down a the tea and manages a half smile. Almost there. He opens the door of the bedroom.

INT. BEDROOM. DAY.

Christine is in bed with Richard. They both sit up gobsmacked. Keith is utterly stunned.

 KEITH
 Christine!

He drops the teacup, we follow its fall in slo-mo. As it hits and slashes we go straight to a violent flash of white light.

ON WHITE

INT. A ROOM. DAY.

There's a lot of white and details resolve out of it. A snow white tablecloth. A silver tray with things for tea laid on it. A white teapot, a white milk jug, a beautiful and capacious white china cup on a white saucer. The scene has a slightly surreal burnish to it.

A MAN, grave and dignified, white gloved picks up the teapot and pours.

 MAN
 The water was freshly drawn, the pot was
 warmed, the tea has been brewed for exactly
 five minutes. The milk is fresh.

He pours the milk. He pours the milk and passes the cup to Keith.
Keith is framed against a white background.

 MAN
 There you go Mr Underwood, a nice cup of tea.

Keith picks up the cup, studies the colour, inhales the aroma.
Then, tentatively, takes a sip. It is a beautiful cup of tea. Perfect.
He gives a beatific smile. He nods slightly. The Man acknowledges his nod
with a satisfied, duty-done nod of his own.

Keith drinks the tea. He puts the cup down. Smiles

 KEITH
 Tea. That's all I need to start the day.

He stands. Instantly two **UNIFORMED MEN** move in on both sides and pinion
his arms behind his back.

The folded handkerchief that the MAN whips out of his front pocket is
a **HOOD.** And a door to the side of the table swings open. Revealing
the **GALLOWS.**

SNAP TO BLACK

MUSIC: I Like a Nice Cup of Tea

Getting started

First draft dialogue is always going to be rough. It is a very unusual writer who can get it right first time. You simply have to accept that it won't read well and that you can revise it later. There are some fundamental questions you must ask about every scene you write: who are the characters and what is their motivation? What do they want out of this conversation? Where are they heading? What baggage do they bring to it?

What you're attempting to write at this stage are lines that say exactly what the character is thinking. In real life, however, we rarely say exactly what we mean. For instance, if we felt inclined to turn down an invitation to a party we didn't want to go to, few of us would say: 'No. I don't want to come, it'll be really boring.' We also tend to find ways to shorten speech, we think of the easiest way to communicate a thought or idea. Therefore your first draft dialogue will be direct and over-long. But don't worry. Just remember the saying: 'Don't get it right, get it written.'

EXERCISES

As dialogue is often the trickiest aspect of any screenplay try the following exercises:

Visualise a courtroom scene. The person who is in the dock is guilty of whatever they've been charged with, but has pleaded not guilty. Write the scene where they are being cross-examined about their offence. Before you start writing, decide whether they are going to break down or not. Remember the barrister's rule that states that you should never ask a question unless you already know the answer. No more than two sides of A4 at 1½ line spacing.

Examine the first draft of *A Nice Cup of Tea*. Rewrite a scene to change the gender of the main character. What effect does this have on the story and what other changes would you have to make to allow the story to work effectively?

Change the time period. What changes to the script directions, descriptions and dialogue do you have to make? Consider what research you would have to undertake to achieve this.

Write a couple of pages of dialogue between yourself as you are now and yourself at the age of twelve.

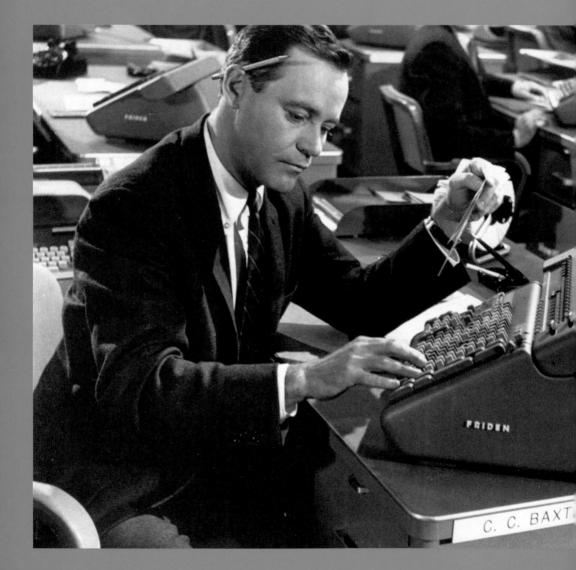

SECOND DRAFT

The Apartment
(dir: Billy Wilder 1960)

Refining your script is essential. Long expositionary dialogue could have been used to let us know about Baxter's predicament. Yet, the recurrent image of Baxter trapped in the vast office says it all without need for words.

It is impossible to set a limit on the number of times a script will need to be rewritten. There does come a point where you have to call a halt – but the really committed writer is always thinking of ways to improve their script.

Once the first draft is finished, there is a tendency to sit back and think that all that will be needed to turn it into a shooting script is a little tinkering. Most first drafts will have major flaws in them. Accepting criticism is often very hard, but it is still, nevertheless, an important skill to develop.

It may be that the criticism strikes at the heart of your script. You – or your chosen critic – may question the entire basis of the story. If this happens, don't panic. Take a deep breath, think about the criticism and see if you can provide an answer.

This chapter contains the second draft of *A Nice Cup of Tea*. This can be read in its own right, but it is worth reading after you have read draft one and the preceding chapter. Many of the issues discussed therein are exemplified by the changes to the script. There are also unnumbered script fragments (from a range of different scripts) that act as exemplars and serve to illustrate specific thematic points within the following chapters.

INT. OFFICE. DAY.

There are two rows of desks. All occupied, bar one. Keith enters, several
people look up. His eyes flit to a glassed-off inner office. He sees the
door's shut. Looks relieved. Hurries across to the unoccupied desk. Sits,
snatches papers from his in-tray.

DISSOLVE TO LATER

The pile of papers in the in-tray has diminished. The pile in the out-
tray has increased. The clock is ticking towards 10.45. Keith massages his
temples, winces and then rubs sore eyes. He looks at the clock longingly.
The minute hand touches the nine.
The door opens. A **TEA LADY** enters, pushing a tea trolley. A vision in white
and silver. The light becomes warmer - as though the sun has just come out.

The tea lady, Denise, is also quite eye-catching. She's younger than you
might expect, dark haired, pretty. Keith smiles at her. And at the large
teapot. Keith's desk is nearest. She comes to him first.

He looks at her, smitten. She lifts the teapot.

She pours the tea, picks up the milk jug. The cup is filled. She places it
on a saucer and hands it to him. He stares at it, catches the aroma and is
about to drink when...

The door of the inner office swings open. **HARRIS**, Keith's boss, stands in
the doorway. He's big, handsome, about forty. Alpha Male. He points a finger
at Keith. Beckons menacingly.
Keith hesitates for a second. Looking at the tea. Harris shakes his head.
Defeated, Keith puts his cup on the desk.

INT. INNER OFFICE. DAY.

We are looking down from a high corner. Keith sits huddled in on himself,
like prey, as Harris circles, drinking a cup of tea.

Keith's headache is now thudding on the soundtrack. We hear the slurping as
Harris drinks his tea. He picks up a sheaf of papers, stapled together, with
his free hand.

He drinks more tea. Keith's eyes follow every movement, longingly.

Dialogue or not?

Although it's not an unbreakable rule, the second draft should see the proportion of dialogue in the script reduced rather than increased. In some cases it may even be possible to eliminate dialogue altogether, or to reduce it to a bare minimum. There are pros and cons to both approaches, some of which are outlined below.

Pros and cons to dialogue-free films

Pros

- Filming is easier if you don't have to deal with recording voices on set.
- Editors may find life easier if they don't have to concern themselves with post-production dubbing of voices.
- The actors have less to worry about. Though film acting is about much more than just dialogue, inexperienced actors may find their job easier if they don't have to remember lines as well as act.
- The film can cross language barriers – the dialogue won't need to be dubbed.

Cons

- Learning to use dialogue effectively is a key part of the screenwriter's apprenticeship. Dialogue-free films won't help you learn.
- Sometimes it's quicker to explain things using dialogue rather than pictures.
- Though character is action (and *vice versa*), dialogue can provide a useful insight into character.
- Thinking of ways to substitute pictures for dialogue is hard work. Dialogue-free films can be harder to write.

The first draft of everything is s***.

Ernest Hemingway

Keith raises his head a fraction, fingers to his temples. A distant rhythmic thud is heard. Keith has a headache. A bad one.

Harris slams the paper on the desk in front of Keith, takes out a pen and writes three words: **MUST DO BETTER**, large and bold. As he does so Keith can smell the tea, can see it only a few inches from his mouth - but it's utterly unobtainable.

CUT TO:

Keith is putting on his overcoat. A COLLEAGUE looks at him and at the cup of tea on his desk. Harris is watching. A little pantomime is performed. The Colleague gestures at the tea, raises his eyebrows in enquiry. Slowly and with infinite sadness, Keith shakes his head. The Colleague takes the tea. Sips. It's a good brew.

INT. CLOSE UP. DAY

Keith is seated on a vile greenish yellow sofa, it's scuffed and filthy. Keith looks very hot. He is sweating, almost panting. An elderly woman is complaining, pointing at papers on her lap and gesticulating.

The room is small and cramped. The **ELDERLY WOMAN** is in her early seventies and none too hygienic-looking. We note a chamber pot tucked under the chair she sits in. We see a fire, blazing. And we see the **CATS**. There are almost too many to count. They cover every spare surface. And they're malevolent-looking cats that plainly add to the smell.
Keith is sickened by the sight of a cat openly urinating in a corner. It isn't discreet. You can *hear* it.

The Elderly Woman follows Keith's horrified, open-mouthed gaze. It doesn't faze her overmuch. She shakes her head indulgently, gets up and shuffles out of the room.

CUT TO

The Elderly Woman is passing him a cup. But it's from a tray with a filthy looking and chipped teapot, a half-empty milk bottle and a sugar bowl full of tea-stained clumps of sugar. As for the cup he's being handed...

It may be china, but it's very hard to tell; the rim is too furry, plastered with cat hairs. He tentatively wipes part of the rim, hairs mat on his fingertip. No. He can't. He blows on it to gain time.

She smiles encouragingly. Keith gives a sickly smile. But he's saved by another cat, a large black beast which has learnt by example; it urinates loudly in a corner. The Elderly Woman turns to look.

Keith seizes his chance. He tips the tea into a plant pot.

EXT. OFFICE BLOCK. DAY.

The main entrance. Keith hurries in.

INT. OFFICE BLOCK. FOYER. DAY.

The big clock reads three minutes to two. The lift doors are open as Keith hares across the foyer to the lift. The doors shut just as he reaches them. He runs for the stairs.

INT. OFFICE BLOCK. FOYER. SIXTH FLOOR. DAY.

It is open and empty. There are two flights of stairs on either side of the lift shaft. Keith stumbles up the left hand one, gasping for breath. The clock on the wall above twin-sets of double doors reads one minute to two. He staggers across the foyer and virtually throws himself through the left hand doors into:

⑤

INT. CANTEEN. OFFICE BLOCK. DAY

It's large and virtually deserted. About half a dozen late diners are just finishing up. The canteen is a 'collect your tray and move along' arrangement. The serving area occupies an entire wall of the canteen, with the kitchens behind. There are rails in front of it to corral the customers.

Keith pays no attention to the **kitchen hands** who are emptying and scraping the trays that contained the food. His glance goes straight to the area by the till. The hot drinks area. He dashes for the start of the rails and virtually runs along as the shutters come down in an almost synchronised fashion.

Each one shuts just as he reaches that section of the serving area. Despairingly, he watches as a **WOMAN** reaches for the shutter that will keep Keith from his goal...

A nice Cup of Tea – 2nd draft, continues page 101

Whose story is this? > **Voice-over** > Making dialogue convincing

She smiles encouragingly. Keith gives a sickly smile. But he's saved by another cat, a large black beast which has learnt by example; it urinates loudly in a corner. The Elderly Woman turns to look.

Keith seizes his chance. He tips the tea into a plant pot.

EXT. OFFICE BLOCK. DAY.

The main entrance. Keith hurries in.

INT. OFFICE BLOCK. FOYER. DAY.

The big clock reads three minutes to two. The lift doors are open as Keith hares across the foyer to the lift. The doors shut just as he reaches them. He runs for the stairs.

INT. OFFICE BLOCK. FOYER. SIXTH FLOOR. DAY.

It is open and empty. There are two flights of stairs on either side of the lift shaft. Keith stumbles up the left hand one, gasping for breath. The clock on the wall above twin-sets of double doors reads one minute to two. He staggers across the foyer and virtually throws himself through the left hand doors into:

(5)

INT. CANTEEN. OFFICE BLOCK. DAY

It's large and virtually deserted. About half a dozen late diners are just finishing up. The canteen is a 'collect your tray and move along' arrangement. The serving area occupies an entire wall of the canteen, with the kitchens behind. There are rails in front of it to corral the customers.

Keith pays no attention to the **kitchen hands** who are emptying and scraping the trays that contained the food. His glance goes straight to the area by the till. The hot drinks area. He dashes for the start of the rails and virtually runs along as the shutters come down in an almost synchronised fashion.

Each one shuts just as he reaches that section of the serving area. Despairingly, he watches as a **WOMAN** reaches for the shutter that will keep Keith from his goal...

A nice Cup of Tea – 2nd draft, continues page 101

No matter how experienced you are as a screenwriter, the temptation is to fall back on dialogue to explain the details of your story. Making dialogue count, making it relevant and realistic is one of the most important skills a screenwriter needs to acquire.

Creating effective dialogue

The first draft of the script *A Nice Cup of Tea* uses a lot of dialogue, whereas in the second draft it is greatly reduced. What is the reasoning behind the change?

The main argument for losing the dialogue is that it is unnecessary – the pictures can tell the story. However, before one takes the decision to eliminate dialogue, it's important to ask if losing it will make the story in any way confusing.

Several key scenes in the first draft rely on dialogue, but it wouldn't be too difficult to alter the scenes to make them dialogue-free. For instance, we don't really need to know why Keith's boss is complaining, or what he's saying. The key factor in the scene is that Keith wants a cup of tea and isn't going to get one. We can *show* that his boss is angry and, by using sound effects, we can suggest that Keith has a bad headache.

In the scene that follows, we don't need to hear the old lady complaining, we just need to know that she is. It's also just as easy to *show* that Keith is hot as for him to say it.

In the end scene, there's no real need for the executioner to say: 'There you go Mr Underwood, a nice cup of tea', but it adds to the film. It's useful to know Keith's name (Underwood connotes someone who is oppressed). Also, the executioner's words will sound soothing after a truly terrible series of events. This is ironic because what's about to happen is anything but soothing. In a later draft, even this might be cut, but in the second draft the words seem to do the job better than actions.

Killing your darlings?

The phrase 'killing your darlings' was coined by the British writer Sir Arthur Quiller-Couch. It means that the writer must be ruthless. Sometimes you will come up with a line or scene that seems unusually good. It may well be unusually good, but the danger is that you will do anything rather than change or cut it – and, however good it is, it may not fit in that particular scene or film.

But too late. The shutter comes down. Enraged, Keith hammers on it.
No response. Keith raises his fist to hammer again, but thinks better of it.
His shoulders slump. He walks away.

INT. OFFICE. DAY.

Keith is working. He has a headache. A very bad headache. Everything seems
extra noisy. He stops to hold his head in his hands. He looks up at the
clock. It's a couple of minutes to three.

He resumes work.

We go in close on the clock. And see the big hand touch the twelve.

Keith puts his pen down, checks his watch. The door opens. Denise enters.
Keith lets out a sigh of relief. He smiles at her. She smiles back. He's
about to say something when the door of Harris's office opens. Harris steps
out. Beckons to her.

Denise smiles apologetically at Keith. She pours a tea and takes it into
Harris's office. The door closes. There is a general frisson of disquiet
around the office - but no-one quite knows what to say.

It is as though time has frozen.

 DISSOLVE TO:

The clock is now at ten past. There is a definite restlessness in
the office.

Keith's headache is plainly excruciating. Suddenly, he decides he must do
something. He stands up, pushes her chair back. Walks towards Harris's
office. Raises his hand to knock, thinks better of it. Then courage returns.
He raps on the door. There's no answer.

He looks at the tea trolley. Raises his hand to knock again. Instead he
grasps the handle and walks straight into:

Cutting doesn't mean that you have to lose material forever – you can always save it in another file, after all. But you must be ready to cut it out if you feel it's not contributing to the story.

Remember, every line and shot in the film must be there for a good reason. It must always be telling us something about story or character. If it's not doing that, it doesn't belong in the screenplay.

Accent

If you are writing a film with dialogue, you may decide to give your characters regional accents. There is nothing wrong with this, but you should be very careful about writing out scripts phonetically.

A phonetically written screenplay where, for example, all the characters speak with Glaswegian accents, will be hard to read. The effort needed will slow down the reader and may well prejudice them against your script. If the reader happens to be a producer this is bad news. No matter how faithful such a script is to the particular accent, it will simply annoy most readers and there's a good chance they'll skip the passages in question.

Even great writers have made this mistake. In *Wuthering Heights,* Emily Brontë does an excellent job of reproducing Joseph's Yorkshire dialect, but most people don't read these passages as they're hard work. It is fortunate that Joseph is a minor character who ultimately adds little to the story.

There's nothing wrong with giving characters phrases that indicate where they're from – but don't overdo it. Remember that having a character say, 'I'll go to the foot of our stairs' does not necessarily make them convincingly from the north of England. Think of their character first – then write the appropriate dialogue.

[Screenwriting] is no more complicated than old French torture chambers, I think. It's about as simple as that.

James L. Brooks

As a general rule, the safest thing is to indicate where the character is from in your biography of them. You can then write their dialogue in fairly Standard English. Leave it to the casting agent to cast, the director to direct and the actor to supply the correct intonation and turns of phrase.

Second draft

INT. HARRIS' OFFICE. DAY.

There is a cup of tea on the desk. But this is not the first thing Keith notices. Or us. Technically speaking, Denise and Harris aren't actually having sex, but they're as close as makes no difference. Keith is appalled.

They spring apart. Denise gasps and starts trying to make herself decent. Harris looks embarrassed but angry.

But Keith is angry too. He picks up the cup of tea and flings the contents all over Harris.

INT. FOYER. OFFICE BLOCK. DAY.

Keith is being escorted from the building by two uniformed **COMMISSIONAIRES**. He is clutching his briefcase and, in the other hand, a brown envelope and various bits of paper.

As he passes the reception desk, the **RECEPTIONISTS** look at him with vague sympathy. They are both drinking tea.

EXT. STREET. CITY. DAY.

Keith is walking along looking somewhat dazed. He passes a very expensive-looking café with a snooty looking **MAÎTRE D'** at the door. In the road, a gang of **WORKMEN** are using a pneumatic drill. It yammers into life. Keith winces. His headache is still bad. Then he looks at the café. He opens his brown envelope. There's quite a lot of cash inside. He turns back.

EXT. CAFÉ ENTRANCE. DAY.

He passes the Maître d' and, airily, flips him a coin.

INT. CAFÉ. DAY.

It's very classy. Keith is seated towards the rear. We can still just hear the occasional staccato bursts from the pneumatic drill but that's not bothering Keith over-much. He's concentrating on the little tea ceremony that is being performed in front of him. A very neatly uniformed **waitress** is about to pour him tea.

(7)

Glossary

Expository dialogue: dialogue that is descriptive and serves only to fill in gaps or to explain a story that is too complex.

One of the key functions of dialogue is to explain the story. Some things are almost impossible to show, so we fall back on speech to let the audience know what is happening. Dialogue that is there to explain is called 'expository dialogue' and there is an art to using it.

Bad expository dialogue really stands out. It consists of characters telling each other things they already know. Here is a simple example. The set-up is as follows:

Greg and Julie are married with two children – a 14-year-old boy and a 12-year-old girl. Greg's mother, who lives nearby, is elderly and he thinks she can't be left on her own any more. He wants to sell his and his mother's houses and use the money to buy a bigger house that they can all live in. Julie is less than keen on the idea.

Here's some really bad **expository dialogue**:

```
                    JULIE
        You're late. Did the engineering factory where
        you work as a section foreman keep you late?

                    JACK
        No, though I did stay on an extra ten minutes
        because there's a good chance that I'll be
        promoted from foreman to supervisor B grade.
        What really slowed me down was stopping to
        look at a large semi-detached house I saw on
        Albermarle Road.

                    JULIE
        You mean Albermarle Road near to where your
        mother lives in a two-up two-down with very
        steep stairs?

                    JACK
        Yes; and I was thinking that seeing as we have
        two children - a 14-year-old boy and a 12-year-
        old girl - we could do with more space than we
        have here. Though it's technically a three-
        bedroomed house, our daughter Holly's room is
        more like a box-room.

                    JULIE
        What you mean is that there'd be more space to
        move your 78-year-old mother in so she can boss
        you around.
```

This is painful stuff, but it's what you might write in the first draft.
In the second draft, you should be looking for ways to convey this
information without the audience noticing that they are absorbing it.

To begin with, one could deal with the issues of the children by having
them in the room or by having a family photo prominent somewhere.
If necessary the daughter could complain about how small her room is.

If Jack truly is a mummy's boy, then we could place a photo of his
mother somewhere prominent – though this would only work if
the audience had already met her. All the other information can be
conveyed in the dialogue:

 JULIE
 You're late. Not more unpaid overtime?

 JACK
 No - promotion, or a good chance of it.
 Supervisor instead of foreman. If it happens,
 we could move.

 JULIE
 We? Who does **we** include?

 JACK
 Just hear me out - there's a semi for sale on
 Albermarle Road. A big semi.

 JULIE
 Albermarle Road? So she wouldn't even have to
 move very far. Jack, I am not moving just so we
 can accommodate your mother.

 JACK
 It's not about my mum, it's about the kids.
 Teenagers need more space than we've got here.
 Especially Holly, her room is more like a box-
 room than a bedroom.

This isn't Shakespeare, but it does convey the necessary information
a little less jarringly than the previous example. Some information has
been left out as unnecessary – like the mother's age and her house
having steep stairs. There will be opportunities to explain this at some
other point, especially if we see the mother's house.

This is a truly impressive tea service; the business. The cup is placed on a saucer in front of Keith. The Waitress lifts the teapot. The pneumatic drill stutters and there is a very loud **BANG.**

This is followed by a flash of blue light. All the lights go out. The Waitress screams, tips the teapot - over Keith's crotch.

EXT. STREET. CITY. DAY.

It's still raining. Keith hurries along the street. And turns into the entrance of a RAILWAY STATION.

INT. STATION BUFFET. DAY.

It's busy, but there are a couple of tables free. The place is self service. He takes a tray and slides it along the counter until he reaches the point at which hot drinks are served. A bored-looking girl of about eighteen stands there. Eventually she notices Keith.

She picks up a pot, picks up a stainless steel infuser on a chain and puts it in the pot. Then she manoeuvres the pot under the spout that spits out boiling water.

The Girl blasts boiling water into the pot. Puts the pot, a cup and saucer, a bowl of sugar and a small jug of milk on the tray.

 DISSOLVE TO:

Keith sitting at a table. He's waiting for the tea to brew. He touches the pot. Looks at his watch. He rubs his hands in anticipation.

Looks at his watch. Drums his fingers. Then notices a sudden in-rush of customers. Looks at his watch again.

He picks up the pot and pours the tea. It's a rich golden brown. Keith's nostrils twitch. It's perfect. He relaxes. At last. He picks up the milk jug. Pours the milk, a pure stream of white. Only it's not. It curdles.

He looks at it with disbelief. Then anger. He picks the tray up and heads towards the counter. But it's now very busy.

He tries to attract the girl's attention but there's a press of customers at the counter. She ignores him.

He puts the tray down on a trolley. And dejected but hurried, heads out onto the platform.

A nice Cup of Tea – 2nd draft, continues on page 111

Second draft

Show rather than tell

The general rule with expository dialogue is that you should first think of ways to *show* the information you want to convey, then if there's no other way of getting it across, you should try to drop it into the dialogue. Remember that dialogue is there to help illustrate character. That is the prime purpose of a line or speech; the information is somewhat incidental.

It's worth remembering that audiences are good at picking up **subtexts**, of building a picture from limited information. Consider the following exchange:

 SUSAN
 Have you seen Mark?

 GREG
 There's a black BMW parked outside
 Laura's house.

 SUSAN
 Is he mad?

This actually tells us quite a lot. It suggests that Mark is doing something he shouldn't and that Susan disapproves very strongly. It could be that Mark and Laura are having an affair, but we don't need Susan or Greg to say this out loud.

Glossary

Subtext: meaning that is not at the forefront of speech but which lies beneath the surface. Hidden meaning intended to be understood with careful reference.

Expository dialogue

Good expository dialogue takes time and practice but as long as you ask yourself:

- Are my characters telling each other things they'd already know?

- Am I over-explaining things?

 …you will find that writing it will come easily and naturally.

Making dialogue more 'real'

The process of making dialogue more 'real' usually involves cutting first draft dialogue and finding ways to reduce the amount of words the characters say; rewriting dialogue involves getting characters to say more with fewer words. First-draft dialogue will be rough, overlong and far more direct than real speech. Your job is to go over it and find ways to bring speech more into line with character and to shorten it wherever possible. In the following example, Adam and Eve are having an affair, though neither can afford for his wife to find out. She's just come close to letting it slip...

 EVE
I'm glad to see you. It's a good thing you're
smart. That was a neat trick you pulled this
afternoon. But did your wife fall for it?

 ADAM
In the sense that she thought I was on
legitimate office business. But she knows I'm
being unfaithful. She just can't prove it
without finding out who. But it's only a matter
of time.

 EVE
You mean it's only a matter of time - unless we
split up?

 ADAM
We both knew there was always a danger she'd
find out. So we don't have a choice. But I
don't want to split up because I'm genuinely
fond of you.

 EVE
I'll miss you too, because I feel the same. And
I'm really quite upset about this even though
it was only ever meant to be a bit of fun.

 ADAM
Yes, me too. I just wish there was some way
round it but I daren't leave her, she'd take me
to the cleaners.

 EVE
But there isn't any way round it. I hoped it'd
be more than just fun and good company, but I
know it can't ever be more. And I really will
miss you quite badly.

 ADAM
I feel like I'm letting you down. You're very
pretty; someone else is bound to come along.
Maybe he won't have a wife they can't divorce.
But you still mean a lot to me, so look after
yourself. One last hug?

By the second draft you could get it down to:

```
                            EVE
          That was fast thinking this afternoon.
          Did it work?

                      ADAM
          She knows I'm playing away from home.
          She just doesn't know who.
          Give her time.

          Eve takes in the implication.
          She looks unhappy.

                      ADAM
          There was always the chance.
          I'm sorry.

                            EVE
          I know. So am I.

                      ADAM
          I guess this is it.

                            EVE
          Yes. It was fun. I'll miss you.

          ADAM
          There'll be someone else. Someone full time.
          Take care...love.

          They embrace.
```

Draft one to draft two – simplifying your script

The second draft contains almost all of the information in the first draft but because it's been pared down, it allows the actors far more space to convey emotions. There are no short cuts with dialogue. You have to listen to the way people speak and learn to experiment with different ways of saying things.

Once again, we *show* in films, and in your second draft you should be thinking hard about your scene descriptions. The way something looks can tell you a great deal.

The screenwriter should always think very hard about how they can use the physical setting, the *mise en scène*, to convey things to the audience. If your central character is very tidy and self-disciplined, it's likely that the place they live will reflect this.

Here's an inadequate description of their room:

```
Int. Living room. House. Day.

It is very neat and tidy. The door opens.
John enters.
```

We have learnt very little from this. Here it is in more detail:

```
Int. Living room. House. Day.

It is bright, clean and minimalist. All the
surfaces are bare, the three-piece suite is
white and spotless. The walls are painted
pastel blue, the windows are shaded with
white blinds.

The only decoration in the room consists of
three small abstract paintings. They are
tasteful, well-framed and expensive. The stereo
system is top of the range. On the shelf above
it are CDs; they fill the space exactly. The
room gives the impression that no one lives
in it; it is like something from a show home,
neutral and lacking in personality.

The door opens. John enters.
```

Even before John has entered the room, we have gained some idea of his character from the place where he lives. Scene descriptions are a very useful tool for writers – it's worth spending time over them.

INT. BUFFET CAR. TRAIN. DAY.

It's busy, but not too crowded. There are about eight or nine customers. Keith is second in the queue. There is a **FAT MAN** – a business type, in front of him, taking a cup of tea from the **STEWARD.**

He lifts up the teapot to pour a tea for Keith. But...

The Fat Man cries out in pain and alarm, drops his tea, clutches his chest and pitches forward. Everyone is stunned, but the Steward recovers fast. He pushes open the half doorway and steps out.

Immediately, everyone is focused on the Steward as he starts to try to help. Everyone except Keith. He's had enough.

He steps behind the counter and pours himself a tea. In a mug. It looks good. He lifts it to his lips just as one of the group gathered round the stricken fatty turns round and – on a nod from the Steward – pulls the communication cord. The train brakes sharply.

The mug flies from Keith's hand. The teapot crashes to the floor.

EXT. HOUSE. STREET. DAY.

Keith walks back to his front door. He looks almost broken. A car is heard passing; he winces. His headache is killing him.

He opens the front door.

INT. KITCHEN. DAY.

Keith is writing a note. It reads:

'Home early. Gone upstairs for a lie down with a nice cup of tea.'

He then shakes a couple of aspirin out of a bottle, puts them in his mouth, washes them down with a glass of water.

He picks up a cup of tea.

A nice Cup of Tea – 2nd draft, continues page 113

Glossary

SFX: shorthand for sound effects. These are normally added to film during the post-production stage.

Diegetic: derived from the Ancient Greek 'diegesis' meaning 'story'. This refers to that which is within the real world of the created story.

Non-diegetic: refers to that which sits outside the created world of the story; for example, dramatic sound effects. Non-diegetic sound effects have to be made explicit as they are far from obvious.

Music and SFX

Music and **SFX** can both add a great deal to a screenplay, but all too many writers either neglect them or simply leave them up to the director. This is a mistake; you should be thinking of your script as a whole; you should be imagining how it will turn out when it's completed.

Music can be **diegetic** or **non-diegetic**. If the music is being heard by the characters, if it's part of the scene, then it's diegetic. If it's not in the scene, if it's been added to create effect, then it's non-diegetic.

For the short film-maker, music can pose problems. Very often the writer wants to use a particular song on the soundtrack, but there are good reasons why you should think twice before doing this. First, it can be expensive. If the song is by a professional musician, then you will have to pay royalties. You will also have to spend time obtaining the necessary permission – and it's not given automatically.

The second issue is to do with distracting the audience. If someone likes the song, they may let their mind drift and start thinking about where they were when they first heard it or who they associate it with. If they don't like the song, then they will be thinking about how much they wish it would end. In neither case will they be giving their full attention to your film.

Songs can also really date a film. They are often associated with particular eras and if you don't want your film to be pinned down date-wise, you need to bear this fact in mind. That said, songs can be a quick way of telling the audience that a film is set in a particular year – though you will also be using *mise en scène*.

Finally, using songs to add to characterisation can be very lazy. Putting a song like *Crazy* on the soundtrack is not the best way to suggest a character is mentally unbalanced. You should be doing this through actions and dialogue.

Sound effects

Like music, these can be diegetic or non-diegetic. With diegetic sound effects it's sometimes tempting to assume that the director or sound recordist will know when to put an effect in. But don't assume – write it into the screenplay.

The screenwriter shouldn't go over the top with sound effects, but they are part of the writer's toolkit and should not be neglected.

Pace and rhythm

The second draft is a good time to consider if you are getting the pace and rhythm of your film right. These can be very hard to judge, but you will get better at it with experience. How the pace and rhythm builds in a script is vital to keep track of.

INT. BEDROOM. DAY.

Keith enters. Christine is in bed with Richard. They both sit up
gobsmacked. Keith is utterly stunned.

He drops the teacup; we follow its fall in slo-mo. As it hits and splashes,
we go straight to a violent flash of white light.

ON WHITE

INT. A ROOM. DAY.

It's white and details resolve out of it. A snow-white tablecloth. A silver
tray with tea things laid on it. A white teapot, a white milk jug, a
beautiful and capacious white china cup on a white saucer. The scene has
a slightly surreal burnish to it.

A MAN, grave and dignified, looking like a high-grade butler and wearing
white gloves picks up the teapot and pours.
A golden stream of tea arcs into the cup. Then he pours the milk and passes
the cup to Keith. Keith is framed against a white background.

> BUTLER
> There you go, Mr. Underwood,
> a nice cup of tea.

Keith picks up the cup, studies the colour, inhales the aroma. Then,
tentatively, takes a sip. It is a beautiful cup of tea. Perfect. He gives
a beatific smile. He nods slightly. The Man acknowledges his nod with a
satisfied, duty-done nod of his own.

Keith drinks the tea. He puts the cup down. Smiles.

He stands. Instantly two UNIFORMED MEN move in on both sides and pinion his
arms behind his back.

The folded handkerchief that the MAN whips out of his front pocket
is a HOOD. And a door to the side of the table swings open. Revealing
the Gallows.

FAST FADE TO BLACK.

SFX – Trapdoor crashes open.

MUSIC: I Like a Nice Cup of Tea - **TITLES**

(10)

A nice Cup of Tea – 2nd draft, continues page 122

**North by Northwest
(dir: Alfred Hitchcock 1959)**

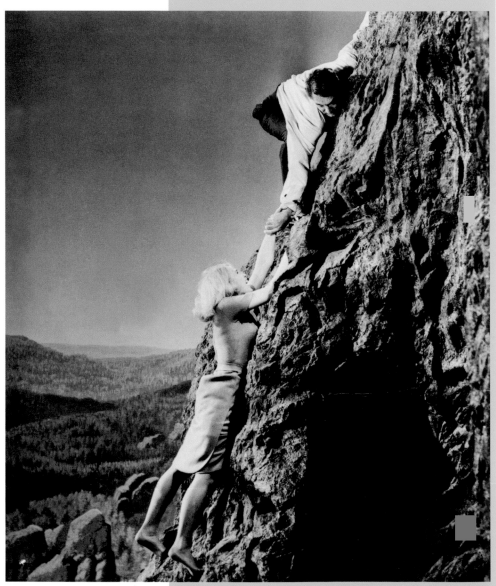

In *North by Northwest*, the beginning establishes both the setting and Roger Thornhill's character and never deviates from this in essence. However, his confirmed bachelor status changes when he meets Eve and the ending on Mount Rushmore cements their relationship as well as his status as a hero. Rushmore's status as iconic symbol of America and democracy is also no accident.

The importance of an effective opening

Many experienced script editors are able to tell whether a script will work within the first five pages. The rule is that a bad opening equals a bad film. Mostly they are dealing with features, but a good, or even great opening is just as important to a short film.

Audiences will often have more patience with a short film than with a feature – probably because they know it will be over sooner – but this doesn't mean that the short film writer can afford to be complacent or lazy about the start of the film. First impressions matter and you should aim to hook the audience from the first shot.

Great opening sequences stay in the memory, and they succeed by working every element. Dialogue, *mise en scène*, symbolism and action should all be establishing theme, character, location and story.

Endings are vital. The ending can determine whether your audience leaves on a high or leaves disappointed. If your film has a twist in the tail, then the ending is where you spring it on the audience. Endings can be so varied that giving advice may seem superfluous; but it is worth making sure that they are punchy, quick and (as with openings) that you use every tool available to the screenwriter to make them work to maximum effect.

EXERCISES

As refining work is always difficult, a good test of your visual storytelling is to take a page of your script, or a page of *A Nice Cup of Tea* and re-write it without any dialogue at all. What happens to the plot when you start to tinker?

Change the perspective of the story. What would happen if you change the main protagonist for another character?

Add a voice-over to the first scene of a finished script. How does this change the nature of how an audience understands the story? You may first want to take a well-known film that already uses a VO and remove it. Comparing the original version of *Bladerunner* with the *Director's Cut* is a useful exercise.

Change the ending of a well-known film. What would have to happen to the rest of the film for this to make sense?

SCRIPT EDITING

**The Bad and the Beautiful
(dir: Vincente Minnelli 1952)**

There is a world of difference between being convinced that your script is great and convincing someone else. As a writer you need to constantly work to close the gap between the images in your mind and what a complete stranger will find on the written page.

In the first instance a script is written to be read. If it is to be taken seriously it needs to have a certain impact and coherence on the page. Before you send your work to a professional script editor or producer, you should be certain that it will hold their attention, make sense, and will deliver your dramatic intentions.

Good creative writing needs good critical reading. Any script benefits from a period of hibernation. At some stage the writing comes to a halt – you get stuck, run out of steam, or feel that the script is finished. Stop for a while; you can always come back to it with renewed vigour and fresh insight later.

This chapter contains the final drafts of *A Nice Cup of Tea*, or at least this was the point at which the writer submitted it as finished. It is useful to have read draft one and two of the script before reading this chapter to fully appreciate the changes. The amendments are enlightening.

Jonathan Shields's determination to be a Hollywood big shot makes him the villain of the piece. His success is at the expense of the writers. Effective script editing is about working with the writer, not against them.

You must cultivate a good critical eye – and ear – in order to spot the basic flaws in a particular script, and assess the general weaknesses in your work as a whole. You need to be able to look down on your own words with a stern and steady gaze. This is the key to developing as a successful screenwriter.

Novice writers often complain that becoming self-critical inhibits them. There is some truth in this; too much self-consciousness can stifle creativity in anyone. But a writer must be a sound judge of their own work. What is needed is *positive* self-scrutiny, which is a matter of balance: too little and you may be fooling yourself, too much and you can't write at all.

Acquiring the necessary objectivity is a hard discipline. But eventually some of that objective awareness will percolate into the act of writing itself, so that you can sense when things aren't quite right, and you won't necessarily have to wait months to figure it out.

Receiving feedback

Of course, another means of gaining critical distance from your work is to invite someone else to read and comment on it. Ideally, they would know something about screenplays. Failing this, you certainly need to find someone who will tell you honestly what they think (good or bad), and who can express their views clearly. There is no point asking the opinion of someone who is afraid to offend you or of someone who can't account for their response.

You also need to be able to listen to, and accept, criticism, which is often very hard when you have put so much of yourself into the project. So the best attitude on both sides is to be business-like. *They* should agree to be forthright, but constructive. *You* should leave your ego to one side, avoid being defensive and not take it personally.

After talking about your film, you may well see it in a different light. They may perceive something you haven't, or find opaque something you thought was perfectly clear. This can be demoralising, but is not catastrophic. The worst thing you can do is to pretend that there isn't a problem and that it will all come right in the end. If there's a fundamental flaw in your concept and you can't see what to do to fix it, then you should put the script to one side and start again on something new.

When you come back to the script much later you may see a solution – or you may not. This happens to the best writers and it doesn't mean another script won't work.

Even if you regard what they have to say as just plain wrong, and decide to stick to your guns (and you *may* indeed be right to do so), the chances are that you will have a much better understanding of the film you are writing than you did before.

**The Apartment
(dir. Billy Wilder 1960)**

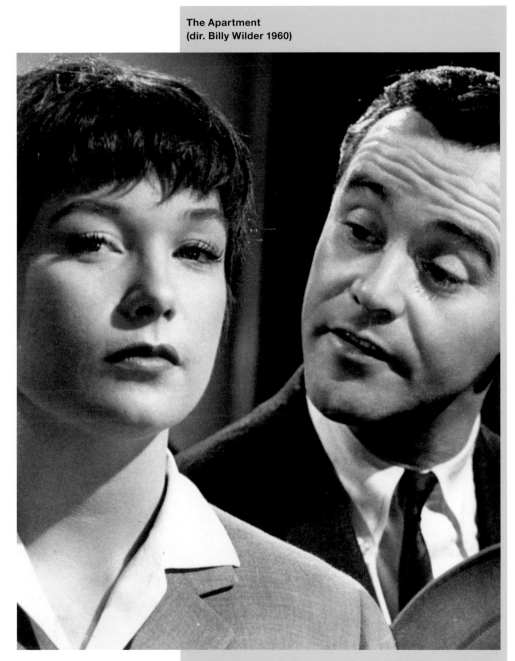

The character C. C. Baxter in Billy Wilder's *The Apartment* is another office worker trapped inside the corporate machine. He thirsts for promotion and the love of Miss Kubelik, until he discovers that she is actually his boss's mistress.

The 'redrafting' that was discussed in Chapter 4 is a matter of pushing the script forward in a particular direction. In contrast, script editing involves a thorough reappraisal of the entire project – observing how each tiny detail relates to the big picture. At every stage you need to invoke the audience by asking: what will they see? What will they hear? What will they be thinking? How will they be feeling? What are they expecting? What do they *want* to happen next?

Using the first two drafts of *A Nice Cup of Tea,* we are going to illustrate the sort of questions that you should apply to your own work. Even with a script as short and comparatively simple as this one, there is a surprising amount to consider, and it is only possible to select a few key issues.

We have chosen this script precisely because it presents some pretty elementary problems. You should regard it as a work-in-progress, and feel free to disagree with both the comments and the changes that have already been made. As you go through, ask yourself what *you* would do faced with telling the same story.

Who are these characters?

The central protagonists must be clearly outlined in terms of their attributes, behaviour and relationships. Only then can they properly exist for the audience. Only then can we be confident that the audience will feel they know and understand them. Without this understanding they won't feel involved in the character's fate, or feel surprised if it takes a sudden unexpected turn.

Do we 'know' enough about them?

This often relates to events which precede the action. Too much back-story can weigh down a film, whereas fragmentary details or veiled hints about a character's past can provide the necessary information in an unobtrusive way. Remember, we are only interested in what has immediate bearing on present events, and helps to explain why they act the way that they do.

If it is important to know that a character has been in prison, there is seldom any necessity to detail every jail-term. It can be more significant and suggestive to have him say: 'I've done time – plenty.' If a woman has been married several times, she only needs refer to 'husband number five' and the impression is made. It tells us everything we need to know.

Because *A Nice Cup of Tea* is a short film, it would be a mistake to try to furnish Keith with a history or complicated personal relationships. In any case, the story is more event-driven than character-driven. Things happen to him, not as a direct result of his personality, but because things happen to everyone. In a sense, he is an 'everyman' figure, representing humanity at large.

Are they adequately 'defined'?

Unless characters are clearly drawn and differentiated, audiences are unlikely to be interested in them. Giving them particular human traits – such as arrogance, shyness, cynicism or naivety – immediately establishes a relationship with the audience, and dictates the degree to which characters appear attractive or sympathetic. These qualities also set up plot expectations. How many films have you seen where pride comes before a fall, or a coward overcomes his fear? Audiences love this.

Unless characters are firmly placed in a social context, their actions and interactions are often impossible to read. Think how unsettling it would be to attend a dinner party where you didn't know who anyone was or how they were related to one another. You would spend most of your time trying to work it out and miss what was being said. Audiences switch off if they feel confused, so characters and their relationships need to be quickly and firmly established.

**The Sixth Sense
(dir: M. Night Shyamalan 1999)**

The plain fact is that audiences are depressingly sophisticated these days, and it is *very* difficult to outwit them. *The Sixth Sense* made its popular reputation by pulling off a major shock in the final reel – and obviously if you *can* do this it is a great point in favour of your script. The danger of this – as with *The Sixth Sense* – is whether you go back to the film once you know the ending. With films like *The Sixth Sense*, *The Usual Suspects* and *The Shawshank Redemption,* the answer is a resounding yes.

EXT. STREET. DAY.

A suburb. A row of thirties semis.

INT. KITCHEN. HOUSE. DAY.

It's very nineteen fifties, cramped and rather shabby. Two children, **JAMES**
aged 11 and **JACKIE** aged 9, sit at a square table which is covered with a
chequered red and white plastic tablecloth. **CHRISTINE** stands by the sink
washing up in a desultory fashion. She's in her mid thirties, attractive
but slatternly. She doesn't look very happy.

Enter **KEITH UNDERWOOD**. He's early forties, harassed-looking and has a bad
shaving cut on his chin plugged with bloodied tissue paper. He's obviously
running late and he isn't very happy either.

Everyone ignores him. Keith goes to a work surface. There is a teapot under
a tea cosy. He looks at a plate on the surface next to the sink. There is a
bacon rind on it. He picks it up like he's a forensic scientist with a vital
piece of evidence. He looks at Christine. She stares back, daring him to
complain. He controls himself.

He picks up a packet of cornflakes from the table. Picks up a bowl. Tips up
the packet. One cornflake falls out. IN SLOW MOTION.

Keith takes a deep breath. Finds a cup and saucer and his actions become
almost ritualistic. He lifts the tea cosy, touches the pot, and yes - it's
hot. He adjusts the cup and saucer, puts the strainer in place and slowly
tips the pot. The tea is hopelessly weak, the colour of peat bog water.
His face falls.

He takes the pot and, slowly and sadly, pours its contents into the sink.

Then he starts looking for the tea, opening cupboards. Christine stands
back, arms folded. James and Jackie look faintly bored. Keith is about to
crack and ask Christine where it is. But he sees the kitchen clock. It says
twenty past eight.

Keith looks at his cheap-looking watch. It says five past eight. He taps it.
It's stopped. This is very bad news.

Christine looks at her watch. It's much nicer than Keith's. Smiles.

EXT. HOUSE. STREET. DAY.

It's raining hard. As Keith hurries down the drive wheeling his rather tatty
and rusty bike, he passes his neighbour **RICHARD**, who's about the same age
but far more self assured; he's also tall, handsome and owns a car.

He's opening the driver's side door. He has an impressive looking vacuum
flask under his arm.

He grins as Keith rides off into the rain. Gets into the car.

EXT. SUBURBAN STREET. DAY.

It's no day to be cycling. Keith is wet and miserable. Passing car and
lorries spray water all over him.

a nice Cup of Tea - final draft, continues page 124

Keith has to occupy his everyman role in a particular way. He must have some signature qualities that differentiate him from everyone else. First impressions are crucial and permanent. His harassed look tells us he is under pressure, but his fixed smile shows us he is putting on a brave face.

From the cold reception he receives from his wife and children, we can see he is under a cloud. What is more, because we are given no specific explanation for this, we have no alternative but to assume that this is the norm. Incidentally, their common disapproval or indifference ensures that he is singled out for our attention, so that we immediately know the film is about him.

Adding details like the shaving cut on his chin suggests a host of things: neglect, weariness, haste, or that he is prone to accidents; all of which will prove to be true.

It would be tempting to go further and make him rather bumbling or give him a stutter, but this would risk making him an outright comic figure, and detract from his 'ordinariness'. He is not a clown; he is just a chap having a really bad day.

Do they engage our sympathy?

The audience must be able to identify with the central character, because only then will they have an emotional foothold in the film. One way to ensure this happens is to position the audience inside the character's perspective. Placing a character in a moral dilemma, imbuing them with a burning passion, or presenting them with an intellectual puzzle, will usually draw the audience towards them emotionally. This is why thrillers, romances and detective stories are so popular.

Having a character treated meanly or unfairly will almost always elicit an audience's sympathy. This is the strategy adopted in *A Nice Cup of Tea*. He may not be a particularly attractive character – he may even be dull – but if the audience empathise with Keith they'll root for him, and later events (however improbable they may be) will take on emotional significance. Even if he later behaves badly, the audience will ultimately forgive him.

Is their motivation clear?

Characters are largely defined by their desires. Desire provides the motivation behind a character's actions, and the main thrust of the narrative. Boy wants girl; cop wants crook. Of course sometimes things can be more complicated and more interesting. Boy wants girl to 'prove' he isn't gay, or cop wants crook in order to grab the loot himself. Simple or not, their desires must eventually make sense and seem appropriate to the person they are.

EXT. RAILWAY STATION. DAY.

We see Keith locking up his bike. He looks up at a station clock, hurries towards the entrance.

EXT. RAILWAY STATION. PLATFORM. DAY.

There's a small hatch behind which a **WOMAN** is serving drinks. Keith has one person in front of him. The tannoy crackles. It's echoey and largely incomprehensible.

The woman is pouring tea from a huge metal teapot. She serves the **MAN** at the head of the queue. He's very slow in finding change. Keith is almost dancing with frustration. A train pulls in. We hear the doors opening. The Man is still fumbling with his change. Finally he pays. Keith makes it to the counter.

The Woman tips the teapot. Keith turns briefly to see the commuters boarding the train. Come on. Come on. The teapot tips further and further – now the spout is pointing straight down. But it's empty. The Woman grimaces. Keith looks deeply frustrated. Behind him a whistle blows – he turns and runs for the train.

EXT. OFFICE BLOCK. DAY.

We see Keith hurry up the steps to the entrance.

INT. FOYER. OFFICE BUILDING. DAY.

It's four minutes past nine. The foyer possesses that quality of echoing emptiness that always makes the late arrival feel highly conspicuous. Two **RECEPTIONISTS** look at him with a mix of pity and interest, like watching a condemned man on his way to the gallows.

INT. OFFICE. DAY.

There are two rows of desks. All occupied, bar one. Keith enters, several people look up. His eyes flit to a glassed off inner office. He sees the door's shut. Looks relieved. Hurries across to the unoccupied desk. Sits, snatches papers from his in-tray.

<div align="right">

DISSOLVE TO LATER

</div>

The pile of papers in the in-tray has diminished. The pile in the out-tray has increased. The clock is ticking towards 10.45. Keith massages his temples, winces and then rubs sore eyes. He looks at the clock longingly. The minute hand touches the nine.

The door opens. A **TEA LADY** enters, pushing a tea trolley. A vision in white and silver. The light becomes warmer - as though the sun has just come out.

The tea lady, Denise, is also quite eye catching. She's younger than you might expect, dark haired, pretty. Keith smiles at her. And at the large teapot. Keith's desk is nearest. She comes to him first.

He looks at her, smitten. She lifts the teapot. She pours the tea, picks up the milk jug. The cup is filled. She places it on a saucer and hands it to him. He stares at it, catches the aroma and is about to drink when...

A nice Cup of Tea – final draft, continues page 130

Motivation in the world of the film

If we ask what Keith wants, the answer is 'not a lot'. Perhaps he doesn't ask for much out of life. Or is he actually a tight knot of repressed passion, all suddenly focused on this one rather meagre objective? Either way, what he wants – a simple cup of tea – he wants *desperately*. Indeed, his motivation could hardly be more acute and, what is more, we all have a pretty good idea how he feels.

If this short film were to expand into a feature film, it wouldn't be tea he was seeking, but probably Denise. Keith obviously likes her, but this short film is not going to be a romance. The reason for making her so desirable in the second draft is that when Keith transfers his attention from a beautiful young woman to a teapot, we are suddenly able to measure the real depth of his thirst!

What stands in their way?

There must be a serious obstacle between the main character(s) and their ultimate objective. Sometimes it is unmistakable; a state-of-the-art security system, disapproving parents, or indecipherable clues. Sometimes it is less tangible; an inner psychological barrier such as fear or guilt, or conflicting emotions that need to be worked through during the course of the story. These are much more difficult to convey on the screen, and require sensitive awareness of human nature. In either case, the difficulty they face must be acute.

Having established that Keith's goal is a refreshing cuppa, the script must place obstacles in his path. In the first draft, Keith's chief obstacle is plain bad luck. This presented a problem because a series of random events is likely to appear rather contrived and perhaps somewhat pointless. Wherever possible, events should not be the result of mere chance, but should arise out of a combination of character and circumstances.

For this reason, the second draft throws more attention on to his wife, Christine, and his boss, Mr Harris. Their thoughtlessness (or deliberate malice) also stands between Keith and what he craves. The enemy (fate, as it were) is given a face.

It is also important that there should be internal obstacles that contribute to Keith's situation. His timidity in the face of authority and general diffidence provide an 'internal' obstacle. It means he cannot assert himself in the way that someone more brash or insensitive might. Can we imagine his wife, his neighbour or his boss in quite the same state?

Where have we seen them before?

Any new character will bear some resemblance to others the audience is already familiar with. Any suave spy will trigger comparisons to James Bond; any fidgety psychotic will remind us of Norman Bates. Most characters belong to a recognisable 'type' – romantic hero, evil mastermind, sad loser – so it can be useful to identify similar figures and learn from the way *they* have been 'drawn'. Even a character as 'unique' as Edward Scissorhands belongs to a long tradition of the lonely and misunderstood outsider.

Keith is a 'type' the audience will recognise (oddly enough this is what will make him seem more real). He belongs to that family of downtrodden men – stretching from Buster Keaton to the character of Lester Burnham in *American Beauty* (1999) – in pursuit of something that eludes them. Although your typical movie hero is active, decisive and resourceful, there is also a place in our hearts for the fall-guy – someone essentially passive, but endearing. Think Woody Allen, rather than Bruce Willis.

What *is* this 'world'?

The environment characters occupy must be coherent, consistent and contribute to how they behave and what happens to them.

Is the setting appropriate?

In many films, the physical surroundings may seem little more than a stage backdrop, but the choice of setting is a crucial and defining one. There are good reasons why thrillers are frequently set in war-torn cities, and why American high schools are favourite locations for romantic comedies. In both cases, the place provides the people and circumstances the story needs, and the audience feels magically 'at home' there.

Even when a story doesn't seem to require any very precise environment, it is of immense value to find one and make it integral to the plot. Being firmly embedded in a specific time and place gives much-needed texture and reality to a film. A given social context imposes certain limitations, but negotiating them can give much-needed definition to the dramatic action.

The value of setting *A Nice Cup of Tea* in 1950s Britain is that for a contemporary audience it summons up very distinct images that immediately add texture and realism to the film. The audience must be in no doubt about the setting, so adding little details such as the chequered table-cloth are essential.

Screen representations of this place and period tend to depict a rather drab, uptight and deferential society, where everyone is meant to know their place, and not step out of line. The film can use these assumptions to explain Keith's meekness in the face of his bullying boss. It also magnifies his tiny act of rebellion, and makes his immediate dismissal – not to mention his execution! – more plausible.

It was also a time of post-war austerity, when tea was the universal pick-me-up. The story would hardly make sense if set in an age of instant gratification, where anyone can grab what they want at a moment's notice.

Distancing the story in time also allows the film to present a somewhat simplified and stylised world, peopled by familiar figures that most viewers would be able to read at a glance.

Do the characters belong in it?

As with any character, before the viewer can know Keith they need to know where he is in the scheme of things. The fact that he lives in a semi, has a wife and two children, and is approaching middle age all help to confirm his 'middling' status.

Yet, the cramped and shabby house and the lack of a car suggest he is even falling short of being Mr Average. Unlike his neighbour Richard, he certainly isn't self-assured or upwardly mobile – but then he isn't nasty either!

Giving him a bicycle in the second draft of the script is another way of further downgrading him socially. More importantly, bicycles can be hard work, clumsy and time consuming – all of which offers valuable opportunities to help convey the pressure he is under.

Facing indifference, disdain and mockery, not to mention the rain – *and all on an empty stomach* – makes Keith seem rather vulnerable. Looking at him the audience will hope for the best, but fear the worst. Will he win out, or will he prove an irredeemable loser?

The script must deliver the story with impact and economy, and script editing involves examining each aspect of the narrative to ensure its contribution is effective.

At this stage, it is likely that whole sections may need to be rearranged, removed or replaced. Indeed, on occasion a radically different perspective may suggest itself – necessitating a complete rewrite.

Is the story being effectively delivered?

This is the moment when you should revisit the Treatment, and assess whether the script is telling the story you want to tell. Is each plot-point presented with sufficient clarity? Is each scene given the appropriate weighting of time and energy? Will the audience be where you want them to be? Will they experience the journey as you intended? Ensuring they do is as much a matter of the arrangement of parts, as it is the actual parts themselves.

Every event and encounter must either move the action forward or add to our understanding of the characters. Then, and only then, will the film hold our attention throughout. As a writer you should be able to argue for the inclusion of every scene, and the value of every dramatic exchange. Then, and only then, can you be reasonably sure that the film will hold together as a whole.

It is crucial to maintain the momentum of the story and avoid unnecessary complication. The structure of *A Nice Cup of Tea* is in no way complex or difficult to follow. Indeed, the plot could hardly be more straightforward – involving, as it does, a series of disappointments concluding in a surprise.

Where is the drama?

Conflict is the lifeblood of drama. Even the lightest comedy is driven by it. Whether it happens between characters or inside them, what grips an audience is the spectacle of people responding to some crisis, and attempting to resolve it.

Knowing that facing conflict is what defines characters and brings a film to life, it is tempting to make characters over active and their gestures too big. Your typical movie hero is decisive and resourceful, takes command of the situation and governs the outcome. But like C. C. Baxter in *The Apartment*, Keith Underwood is someone buffeted by events; driven forward by desire, but beaten back by fate, time and time again.

The second draft deliberately emphasises the lack of effective interaction between Keith and his world. The opening scene is dominated by silence, the reprimand from his boss is almost conducted in mime, and the strange encounter with the cat woman is characterised by mutual incomprehension. These scenes will have a quiet drama of their own. Being ignored, silenced and misinterpreted, our attention turns to what must be happening to Keith on the *inside*.

Is there a rhythm to events?

Any script is organised around moments of heightened emotion. Being able to identify these moments, maximise their impact and arrange them effectively, is an essential part of any storyteller's art.

In addition to ensuring that the nature of the conflict is clearly established, it is important that it unfolds in a pleasing way. Depending on the nature of the tale, this might involve a gradual and relentless escalation of tension or an alternating rhythm of suspense and stillness.

Because *A Nice Cup of Tea* is built on a pattern of recurrence, there is a danger that events will seem merely arbitrary and that the film as a whole will seem shapeless – as if it could stop at any point or go on indefinitely. It is important to ensure that each repetition adds something different and interesting. So each cup of tea Keith fails to drink has a distinct quality – too weak, too slow, too curdled or too hairy! – in order that it presents an element of surprise or irony.

Is the action believable?

This is not necessarily a matter of realism. As long as characters act with internal consistency and do not step outside the limits of the fictional world they inhabit, then almost anything can be believed. We readily accept that Superman can save Lois Lane by flying at incredible speed around the earth, and turning back time. If he were suddenly to reveal he had built a time machine in his basement, our ability to suspend disbelief would suddenly collapse.

In *A Nice Cup of Tea*, Keith steps out of character at least once with disastrous results. Surely he is too timid to assault his boss – let alone risk his job! But this is the moment when the conflict within him is at its greatest. His acquired thirst meets his innate diffidence – and his thirst wins out. But why does Keith behave like a wronged spouse? He may indeed feel some sexual jealousy, but nobody is betraying *him*. To address this discrepancy, the second draft emphasises Keith's *idealisation* of Denise. He is reacting to his 'Goddess of the Urn' being defiled – to the fall of his idol.

Of course, the viewer *shouldn't* be prepared for the violence of Keith's response, which is why the second draft deletes his earlier outburst in the kitchen (throwing the pot of tea in the sink), and shows him fighting the impulse to hammer on the closed shutter in the canteen. His sudden violent action might be seen to exemplify a psychological truth, which the audience will recognise. Unaccustomed to expressing anger, once roused, he can't control himself and goes too far. Like his colleagues at work, the audience will say, 'he suddenly snapped'. And having once overstepped the mark, nothing will ever be the same again.

Analysis: character and world > **Analysis: action, interaction and structure** > Analysis: word and image

The door of the inner office swings open. **HARRIS**, Keith's boss, stands in the doorway. He's big, handsome, about forty. Alpha Male. He points a finger at Keith. Beckons menacingly.

Keith hesitates for a second. Looking at the tea. Harris shakes his head. Defeated, Keith puts his cup on the desk.

INT. INNER OFFICE. DAY.

We are looking down from a high corner. Keith sits huddled in on himself, like prey, as Harris circles, drinking a cup of tea.

Keith's headache is now thudding on the soundtrack. We hear the slurping as Harris drinks his tea. He picks up a sheaf of papers, stapled together, with his free hand.

He drinks more tea. Keith's eyes follow every movement, longingly.
Keith raises his head a fraction, fingers to his temples. A distant rhythmic thud is heard. Keith has a headache. A bad one.

Harris slams the paper on the desk in front of Keith, takes out a pen and writes three words: **MUST DO BETTER**, large and bold. As he does so, Keith can smell the tea, can see it only a few inches from his mouth - but it is utterly unobtainable.

<div align="right">CUT TO:</div>

Keith is putting on his overcoat. A COLLEAGUE looks at him and at the cup of tea on his desk. Harris is watching. A little pantomime is performed. The Colleague gestures at the tea, raises his eyebrows in enquiry. Slowly and with infinite sadness, Keith shakes his head. The Colleague takes the tea. Sips. It's a good brew.

INT. CLOSE UP. DAY.

Keith is seated on a vile greenish-yellow sofa, it's scuffed and filthy. Keith looks very hot. He is sweating, almost panting. An elderly woman is complaining, pointing at papers on her lap and gesticulating.

The room is small and cramped. The **ELDERLY WOMAN** is in her early seventies and none too hygienic-looking. We note a chamber pot tucked under the chair she sits in. We see a fire, blazing. And we see the CATS. There are almost too many to count. They cover every spare surface. And they're malevolent looking cats that plainly add to the smell.

Keith is sickened by the sight of a cat openly urinating in a corner. It isn't discreet. You can **hear it.**

The Elderly Woman follows Keith's horrified, open-mouthed gaze. It doesn't faze her over-much. She shakes her head indulgently, gets up and shuffles out of the room.

<div align="right">CUT TO</div>

The Elderly Woman is passing him a cup. But it's from a tray with a filthy looking and chipped teapot, a half-empty milk bottle and a sugar bowl full of tea-stained clumps of sugar. As for the cup he's being handed...

It may be china, but it's very hard to tell; the rim is too furry, plastered with cat hairs. He tentatively wipes part of the rim; hairs mat on his fingertip. No. He can't. He blows on it to gain time.

a nice Cup of Tea - final draft, continues page 131

She smiles encouragingly. Keith gives a sickly smile. But he's saved by another cat, a large black beast which has learnt by example. It urinates loudly in a corner. The Elderly Woman turns to look.

Keith seizes his chance. He tips the tea into a plant pot.

EXT. OFFICE BLOCK. DAY.

The main entrance. Keith hurries in.

INT. OFFICE BLOCK. FOYER. DAY.

The big clock reads three minutes to two. The lift doors are open as Keith hares across the foyer to the lift. The doors shut just as he reaches them. He runs for the stairs.

INT. OFFICE BLOCK. FOYER. SIXTH FLOOR. DAY.

It is open and empty. There are two flights of stairs on either side of the lift shaft. Keith stumbles up the left hand one, gasping for breath. The clock on the wall above twin-sets of double doors reads one minute to two. He staggers across the foyer and virtually throws himself through the left hand doors into:

INT. CANTEEN. OFFICE BLOCK. DAY.

It's large and virtually deserted. About half a dozen late diners are just finishing up. The canteen is a 'collect your tray and move along' arrangement. The serving area occupies an entire wall of the canteen, with the kitchens behind. There are rails in front of it to corral the customers.

Keith pays no attention to the **KITCHEN HANDS** who are emptying and scraping the trays that contained the food. His glance goes straight to the area by the till. The hot drinks area. He dashes for the start of the rails and virtually runs along as the shutters come down in an almost synchronised fashion.

Each one shuts just as he reaches that section of the serving area. Despairingly he watches as a **WOMAN** reaches for the shutter that will keep Keith from his goal...

But too late. The shutter comes down. Enraged, Keith hammers on it. No response. Keith raises his fist to hammer again, but thinks better of it. His shoulders slump. He walks away.

INT. OFFICE. DAY.

Keith is working. He has a headache. A very bad headache. Everything seems extra noisy. He stops to hold his head in his hands. He tips up his aspirin bottle; an aspirin falls out. He puts it in his mouth and swallows it. It's not easy swallowing a dry aspirin and the strain shows.

He looks up at the clock. It's a couple of minutes to three. He resumes work.

We go in close on the clock. And see the big hand touch the twelve.

Keith puts his pen down, checks his watch. The door opens. Denise enters. Keith lets out a sigh of relief. He smiles at her. She smiles back. He's about to say something when the door of Harris's office opens. Harris steps out. Beckons to her.

Denise smiles apologetically at Keith. She pours a tea and takes it into Harris's office. The door closes. There is a general frisson of disquiet round the office – but no-one quite knows what to say.

A Nice Cup of Tea – final draft, continues page 132

Analysis: character and world > **Analysis: action, interaction and structure** > Analysis: word and image

It is as though time has frozen.

DISSOLVE TO:

The clock is now at ten past. There is now a definite restlessness in the office. Keith's headache is plainly now excruciating. Suddenly he decides he must do something. He stands up, pushes her chair back. Walks towards Harris's office. Raises his hand to knock, thinks better of it. Then courage returns. He raps on the door. There's no answer.

He looks at the tea trolley. Raises his hand to knock again. Instead he grasps the handle and walks straight into:

INT. HARRIS' OFFICE. DAY.

There is a cup of tea on the desk. But this is not the first thing Keith notices. Or us. Technically speaking, Denise and Harris aren't actually having sex, but they're as close as makes no difference. Keith is appalled.

They spring apart. Denise gasps and starts trying to make herself decent. Harris looks embarrassed but angry.

But Keith is angry too. He picks up the cup of tea and flings the contents all over Harris.

INT. FOYER. OFFICE BLOCK. DAY.

Keith is being escorted from the building by two uniformed **COMMISSIONAIRES**. He is clutching his briefcase and, in the other hand, a brown envelope and various bits of paper.

As he passes the reception desk, the RECEPTIONISTS look at him with vague sympathy. They are both drinking tea.

EXT. STREET. CITY. DAY.

Keith is walking along looking somewhat dazed. He passes a very expensive-looking café with a snooty-looking **MAÎTRE D'** at the door. In the road, a gang of **WORKMEN** are using a pneumatic drill. It yammers into life. Keith winces. His headache is still bad. Then he looks at the café. He opens his brown envelope. There's quite a lot of cash inside. He turns back.

EXT. CAFÉ ENTRANCE. DAY.

He passes the Maître d' and, airily, flips him a coin.

INT. CAFÉ. DAY.

It's very classy. Keith is seated towards the rear. We can still just hear the occasional staccato bursts from the pneumatic drill but that's not bothering Keith over-much. He's concentrating on the little tea ceremony that is being performed in front of him. A very neatly uniformed **WAITRESS** is about to pour him tea.

This is a truly impressive tea service; the business. The cup is placed on a saucer in front of Keith. The Waitress lifts the teapot. The pneumatic drill stutters and there is a very loud **BANG.**

This is followed by a flash of blue light. All the lights go out. The Waitress screams, tips the teapot - over Keith's crotch.

A nice Cup of Tea - final draft, continues page 139

Do characters 'develop'?

Characters *must* be changed by events, or by those events that seem meaningless. The second draft attempts to address this by adding details that clarify the escalation in Keith's feelings of frustration and bewilderment. He gradually changes from a sensitive person who avoids giving offence ('smiling weakly and apologetically' as though *he* is causing the delay at the station kiosk) to someone who can overlook a fellow passenger having a heart attack.

To achieve this, every scene has to be a precise report on his mentality. The slow course of this transformation is what will hold the film together.

Is anything redundant or missing?

Where something seems lacking or incomplete, it is tempting to insert an entirely new scene, but this often necessitates other major changes and can easily endanger the integrity of what is already there. It is therefore crucial to be as precise as possible about what seems to be missing, and ask yourself whether it justifies wholesale alterations, or can be supplied by a modest addition of a remark or piece of action.

The script must unfold something new at every stage, and the worst sin is to include redundant scenes or excess dialogue. The repeated test is to ask the following questions: what job is this doing? Why does the viewer need to see or hear this? What would be lost if this was cut?

The scene on the morning train in the first draft of *A Nice Cup of Tea* proved dispensable. The original idea was to create a sense of symmetry with the train journey home, and a contrast with Keith's state of mind later in the day. But it doesn't add anything extra in terms of humour or pathos.

In the first draft – between getting fired and heading home – Keith has another disappointment in a rather *posh* cafe. The second draft expands this scene to let the audience know how he has been affected by losing his job. The unfortunate encounter with the workmen shows how rattled Keith is. Yet, feeling suddenly liberated – released from his bonds – he starts to indulge himself.

In addition to 'global' issues of story and structure, the impact of each spoken word and visual image needs to be carefully weighed.

Does every word count?

The revised draft of *A Nice Cup of Tea* strips away most of the dialogue; and this process could continue. However, there are specific reasons in each case. Words plant ideas, and it is very important that they are not the wrong ones.

Bringing up the sensitive issue of money is likely to mislead the audience into expecting this to be an important factor in the story. Indeed, there is a danger that an over-developed argument between husband and wife will signal that the film is about *them* – their marriage – which is only partially true.

Similarly, Harris's harassment of Keith – on the charge of sloppiness – suggests that he is *always* late, which takes something away from the exceptional nature of this particular day. Both lines of thought are irrelevant and distracting.

**American Beauty
(dir: Sam Mendes 1999)**

Like Lester Burnham in *American Beauty*, Keith Underwood is in search of something to restore himself to himself. Being a short film, this universal theme can be given an unusually novel slant. For Lester it is lost youth and sexual pleasure. For Keith it is a good brew – but it is essentially the same thing.

Is the script sufficiently visual?

This is not a matter of suggesting specific visual effects, but exploiting film's capacity to 'talk in pictures'. The thoughtful use of locations, objects and physical action can enact a good deal of the story with little need for dialogue. An extreme example is the use of big social occasions to provide a theatrical structure in films such as *The Godfather* and *Four Weddings and a Funeral*.

Tiny rituals – small intimate acts such as lighting a cigarette or loading a gun – also play a very important part in movies, providing visual equivalents for otherwise invisible thoughts and feelings. Film can pick out and linger on physical objects and human behaviour in the way that gives them an erotic or spiritual quality.

A Nice Cup of Tea is built around a very common ritual, which has a kind of theatricality – props, actions and language – which the script should capitalise on. The tinkle of silver on china will add a sprinkle of music to the film.

The second draft adds little visual touches – smacking his lips, wiping his mouth, stroking his throat and pulling at his collar – that together convey Keith's mounting distress. The point-of-view images of cups and saucers (literally dashed from his lips) put the viewer inside his feelings of anticipation and disappointment.

Writers are always on the lookout for images that can cluster into themes. The repetition of steam and whistles – issuing with ever-increasing intensity from kettles and trains – cluster together to convey an impression of internal pressure and suggest the danger of something boiling over.

In the second draft, this theme is underscored by giving Keith a headache and a packet of pills. Not only is this perfectly consistent with the situation, but it encourages the audience to feel what Keith feels. Most of us would wince seeing someone trying to swallow an aspirin dry!

Other images are incorporated into the script to visually encapsulate Keith's circumstances. The single cornflake conveys emptiness more effectively than would a completely empty box. Showing it tumbling around the breakfast bowl in slow motion not only arrests the audience's attention but gives them a moment to reflect on what it signifies.

**Coffee and Cigarettes
(dir: Jim Jarmusch 2003)**

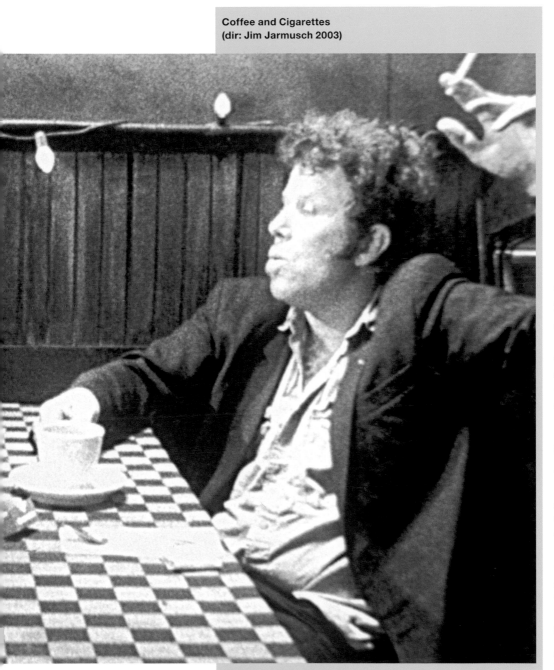

Examine *Coffee and Cigarettes*, a collection of shorts directed by Jim Jarmusch, for the way specific and sparse detail can be used to convey what is left unspoken.

Analysis: action, interaction and structure > **Analysis: word and image** > Analysis: closure/ambiguity

We have stressed throughout the book so far the need to constantly assess the effect the script is having on the reader and/or the audience. This is never more important than when writing the final pages.

Does the ending satisfy?

The aim has to be to leave the viewer *precisely* where you want them; which can mean in a state of complete satisfaction or with some lingering question, which invites them to speculate on what will happen next. The shooting script of *The Silence of the Lambs* is a good example of the latter. As Hannibal Lecter slowly disappears into a crowd, we wonder about his next meal.

Most shorts attempt to surprise their audience with a final trick up the sleeve – a shock revelation or an ironic reversal of fortune. And as long as it isn't too contrived or predictable, this can be very rewarding. Asking the audience to read the note Keith writes to Christine *is* perhaps a rather awkward way to inform them that he has returned home early. However, they *do* need to be told, or what follows won't make sense.

The husband coming home to find his wife in bed with the next-door neighbour is a bit of a cliché. Well, more than a bit of one actually. But clichés are not necessarily to be despised. We are so familiar with them precisely because they *work*. The delight we take in such things is primitive, but inexhaustible.

However, there is a considerable danger in straining too hard for that jaw-dropping, out-of-the-blue *coup de grâce* that will lay the audience out flat. Most stories can only plausibly end in a limited number of ways, and even when an audience has a general sense of what is about to happen, there is still a lot of room to make the ending interesting and unusual.

Is the ending suitable?

It is important that the film deserves the ending it is given, or that the ending suitably rounds off the film. Audiences don't mind seeing the ending coming, as long as it is consistent with what has preceded it and is executed with a certain aplomb.

The conclusion to *A Nice Cup of Tea* echoes some of the images we have already encountered. Not only does Keith's day end where it began, but he returns to find another pair of embarrassed lovers. We're led to speculate whether this second blow to his innocence strikes him more – or less – deeply than the first.

The slowness with which the cup falls from his hand instantly reminds us of the cornflake, and ties the film together thematically. Perhaps his marriage is as empty as the cereal packet. Additionally, the unnatural special effect nudges the film into its slightly surreal finale.

EXT. STREET. CITY. DAY.

It's still raining. Keith hurries along the street. And turns into the entrance of a RAILWAY STATION.

INT. STATION BUFFET. DAY.

It's busy, but there are a couple of tables free. The place is self service. He takes a tray and slides it along the counter until he reaches the point at which hot drinks are served. A bored-looking girl of about eighteen stands there. Eventually she notices Keith.

She picks up a pot, picks up a stainless steel infuser on a chain and puts it in the pot. The she manoeuvres the pot under the spout that spits out boiling water.

The Girl blasts boiling water into the pot. Puts the pot, a cup and saucer, a bowl of sugar and a small jug of milk on the tray.

 DISSOLVE TO:

Keith is sitting at a table. He's waiting for the tea to brew. He touches the pot. Looks at his watch. He rubs his hands in anticipation.

Looks at his watch. Drums his fingers. Then notices a sudden in-rush of customers. Looks at his watch again.

He picks up the pot and pours the tea. It's a rich golden brown. Keith's nostrils twitch. It's perfect. He relaxes. At last. He picks up the milk jug. Pours the milk, a pure stream of white. Only it's not. It curdles.

He looks at it with disbelief. Then anger. He picks the tray up and heads towards the counter. But it's now very busy.

He tries to attract the girl's attention but there's a press of customers at the counter. She ignores him.

He puts the tray down on a trolley. And dejected but hurried, heads out onto the platform.

INT. BUFFET CAR. TRAIN. DAY.

It's busy, but not too crowded. There are about eight or nine customers. Keith is second in the queue. There is a **FAT MAN,** a business type, in front of him, taking a cup of tea from the **STEWARD.**

He lifts up the teapot to pour a tea for Keith. But...

The Fat Man cries out in pain and alarm, drops his tea, clutches his chest and pitches forward. Everyone is stunned, but the Steward recovers fast. He pushes open the half doorway and steps out.

Immediately everyone is focused on the Steward as he starts to try to help. Everyone except Keith. He's had enough.

He steps behind the counter and pours himself a tea. In a mug. It looks good. He lifts it to his lips just as one of the group around the stricken fatty turns round and, on a nod from the Steward, pulls the communication cord. The train brakes sharply.

The mug flies from Keith's hand. The teapot crashes to the floor.

a nice cup of tea - final draft, continues page 140

Analysis: word and image > Analysis: closure / ambiguity > After effects and meaning

The one overriding quality that any script must have – and without which it will never leave the page – is *stickiness*. It has to stick in the reader's mind, hopefully for the right reasons. If it is instantly forgettable, no one will go back to it, let alone consider making the considerable investment in time and money necessary to make it into a film.

Is this script memorable?

The central idea of *A Nice Cup of Tea* is simple, and the execution is relatively straightforward. The central character gives it a strong human core. It takes us on a journey through experiences that are by turns common, quirky and terrible. The events have a rhythm that is easy to catch and it is clear enough where the points of crisis, climax and closure occur. There are local pleasures and there is a pleasing arc to the story as a whole.

A film-maker could choose to emphasise the farcical surface or the darker aspects. It could be a cry against hostility from a merciless God, or a study in psychological breakdown. Neither comedy nor tragedy, it could embrace both. It blends realism and fantasy in an open and appealing way.

Where are the weaknesses?

This is where *you* must bring your own critical faculties to bear. We would say that there are inevitably problems yet to be addressed. What do you think?

Making meaning

Note: it would make an enormous difference if instead of a cup of tea he was desperate for a glass of water or a bottle of whisky. It would radically alter who Keith *is*. Water would signify a purely physical and impersonal need: we all need water to survive. Whisky would suggest psychological dependency, which amounts to an illness.

Yes, tea *does* slake your thirst (and it *can* be addictive), but in the context of Keith's story it is something medicinal, a healing balm. It represents a brief respite from the pressures of a demanding life – me-time. That the world conspires to deny him even this tiny crumb of comfort seems very cruel. It isn't a lot to ask – and *that's* the point.

In other words, the cup of tea is *symbolic*, and – however unlikely it may appear – this story really is a Grail Quest.

Talking about the script in such grandiose terms may seem ridiculous, but it can help the writer to unshackle themselves from the particular details of the plot and to glimpse both the bigger picture of the story they are telling and its meaning. *A Nice Cup of Tea* (like *The Apartment* and *American Beauty*) actually touches on a deep truth: that the meaning of life is to be found in the small things we usually overlook, because they cost us little and are right under our nose. Film is a wonderful medium for capturing this idea.

In a Western, Keith would be the homesteader fighting cattle barons for the water he needs to farm his land. In a Film Noir, he would be the hapless guy seduced by a dangerously intoxicating blonde, and getting hopelessly ensnared in a life of crime. As befits our little (and very British) film, Keith is a nondescript office worker trying to escape for a few heavenly moments from the crushing daily routine of an unsympathetic world.

As a writer, you can reasonably trust that the audience will sense this, even if they don't conceive of it in these terms. We all desire some kind of escape. If Keith looks a little pathetic, it is because there is something childlike in his obsession. But we all have that child still within us.

EXERCISES

As this chapter has established, script editing is very much as it sounds: looking at the work of others and providing positive and helpful feedback. The best exercise that can be undertaken is to swap scripts with a fellow writer and discuss the pros and cons of what has been written. In addition to this, try the following exercises:

Take a script you have written. Summarise the story on one side of A4. Match it against your treatment. Realistically assess what has changed.

Take a pre-existing script for a film you have not seen. What notes would you give the writer? Watch the film: has the process of it being made changed what was written down on the page or translated it more or less directly to what appears on the screen before you?

Take a script from a film you are familiar with. What has been left out, amended or changed in translation to the screen?

SCREENWRITERS: UNSCRIPTED

**Little Voice
(dir: Mark Herman 1998)**

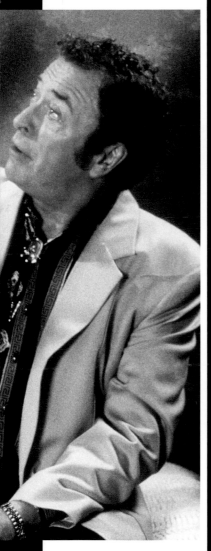

In *Little Voice*, Ray convinces
Little Voice that she should be a
star; but it is for his own benefit.
When listening to advice from
others, always remember that all
writers are still practising.

This chapter is intended to provide some contextual
information – not advice. Throughout the majority of
this book we have provided you with some advice
and a few rules – but mainly guidelines about
process. This identifies the norm, but to quote Monty
Python's *Life of Brian:* 'You are all individuals…'.
Process in screenwriting has been developed
over more than one hundred years and it works,
but everyone varies their practice. As a budding
screenwriter, one thing that has to be reiterated is –
PRACTISE. A writer writes.

Some of the people you will hear from are well-
versed in the art of screenwriting. Some are newer to
the profession. All of them have found a way to work
that suits them and suits the nature of the script they
are working on.

You will read contradictions – not many, but some.
These contradictions are not intended to confuse
but rather to form the left and right edges of a path.
Sometimes you will walk a little further to the left,
sometimes to the right, but you will never leave the
path. How's that for a metaphor?

People like it; some people didn't get it and would prefer a beginning, middle and end and a bad guy, but it didn't have those! Still, most people like it.

Alisha McMahon: Writer/Director *Floored* 2008

A former student of Film and Television Production, Alisha is experienced in short film production with particular skills as a Production Designer and Art Director. *Floored* marks her first film script – written after frustration with seeing lots of conventional drama on screen – which she also directed. *Floored* is a film with one main character who simply wants to get home. The hero's journey is consistently interrupted by a series of bizarre individuals confined within an apartment block. Alisha is currently working on her second short film script and her next project involves working with Peter Hunt on *Elevator Gods*.

Where did your ideas come from?

My crazy messed-up head! I love music videos and how you pass off the strange, and had drawn up the concept for a music video based around death. I came up with the idea of the characters stood in the block of flats and it came from there. Once I had my main character, it was just a question of how many crazy characters I could put in.

A lot of the inspiration came from music videos and what the image can do. It's all about how you can tell a story in three minutes. I took that as the starting point. The idea for the film came from a video I was asked to do for a band called Hijak Oscar – I thought of a person trying to get home and I took it from there.

Floored is much more absurdist in approach and eschews conventional narrative forms. How did you contend with this?

The narrative emerged after I watched *After Hours* and [its theme] of just wanting to get home. As soon as I knew [the main character] wouldn't get home, it was a case of working out what and who would stop him.

Where did you start the writing process?

I wrote a log line partly because I needed to, but [also] it was a case of finding enough words – this was after the second draft.

Did you go for a treatment straight away?

I went straight into a script and then went back to write a step treatment. When I had the second draft I was able to tighten it. The treatment was an essential communication tool.

How did you prepare for your pitch?

The pitch was terrifying. I did so much preparation. I rehearsed and prepared a PowerPoint [presentation] but on the day we couldn't use it so everything went out the window! I needed to get the story across. I couldn't just say 'it's a comedy'. I needed to appeal to people and so had to sell it visually. In the end I just read off the treatment! The nerves didn't help. But they pushed me to stick by the script.

Alisha McMahon > James Condon

What helped you develop the structure of your pitch?

I wrote the treatment before the pitch because it helps with the script. [This way] you can put the most important elements down and explain the main character and his mission and the other characters.

The most essential part of the pitch was summarising the visuals and this helps people connect.

How did you develop your characters?

I initially had 20 characters but had to cut it down! This meant I could assign more to each character and give them more to do and make them more rounded people.

How did you contend with dialogue – the hardest part of screenwriting?

Dialogue was the hardest. The way I speak isn't necessarily the way a 50-year-old man living with his mother would speak. I passed the script to other people and listened to the way people speak. In the end it was very stylised so it was possible to do lots of things with it but it still had to make sense.

How did you set about structure with such an unusual script?

I didn't want a beginning, middle and an end. I don't believe it has to be resolved or [that there has to be] a happy ending. As long as you keep someone entertained and keep them interested for 12 minutes you can cut out all the boring bits and take them on a journey. That's what this film was about – a man on a journey. In a way, everyone can empathise with this. He just wants to get home and we all feel like that at times.

How did you work with a script editor?

I had written stories before but this was my first script. I worked with Emily Barker and thought we'd work together in the same room, but we ended up with me writing a chunk of work and sending it to her. Emily would amend it and send it back to me. It was great [...] we talked about what we'd changed and why. It was a really good way of working with Emily as script editor at each point of the draft – although she did much more than a normal script editor would.

And audience reception of the finished film...

People like it; some people didn't get it and would prefer a beginning, middle and end and a bad guy, but it didn't have those! Still, most people like it.

Floored takes a non-standard view of narrative. It is also largely bound by a single location – the interior of a block of apartments. In this way it is also unusual in that it was conceived and filmed in a studio.

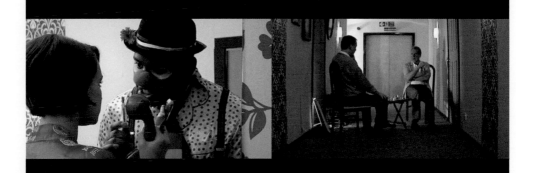

Cutting my teeth as a film-maker, I wanted to test myself without falling back on dialogue. This is as hard at the script stage as at the directing stage.

James Condon: Writer/Director *Snowed Under* 2008

James Condon came to film primarily as a writer. His enthusiasm for writing is balanced by recognition of the importance of the whole film production process. James became a student of Film and Television Production and undertook several work placements with a range of production companies. *Snowed Under* is his first major short film (which he both wrote and directed), and is a piece about isolation and desire with supernatural overtones. James has a range of interests and skills in the field of film production including writing and directing. James is currently with Working Title films and continues to develop his own scripts.

Where did your ideas come from?

At the time of writing I wasn't aware of my inspiration. It came out of being a first-year undergraduate and working a lot and writing in a Starbucks at lunchtimes in Hull. It came out of the time pressures. The inspiration was hidden but looking back it was more to do with my life at the time.

Your idea was very personal; how did you make it accessible for an audience?

The subject is potentially dangerous for a writer – being too personal. It's a bit tricky being too aware too early on of how personal things are. Better if it's seeping through your subconscious. A good story will appear to spring out of nowhere, but looking at it later and refining it will make it more audience-friendly.

Where did you start the writing process?

I started with a 25-word punchy log line... once I'd given it enough in that format it moved to a step treatment. I used a log line but went through a number of different log lines. Crossing them out. If it's not right at that stage then it's not going to work later.

What came next?

Then I went to a story beat/draft. A very rough treatment. The idea lent itself to the structure. Because I was writing the story with a view to making a punchy story when I was filtering it, I was selecting it for that form so it was straightforward to move to a step outline.

Did following the conventional developmental process help you with structure?

There was no particular problem with the structure. It was what lent itself to the idea at the time.

How did you prepare for your pitch?

The idea had been worked through before the pitch. When the idea originated, I had to pitch an idea and take it to the group and informally pitched it to the crew. I had to pitch over the phone – and was lucky because I had a very punchy log line – I could say what it was about, who it was about and why we should be interested in this – the poster/back of DVD blurb.

How did you develop your characters?

Dealing with one character mainly helped. There is only one scene where two characters interact. The dialogue couldn't be frivolous. Not that it ever should be in any film! With so many scenes [featuring] one person on his own, it forced having to think carefully about how the film would show what's happening. It was important to keep thinking about the original concept and what the film was actually about.

How did you contend with dialogue – the hardest part of screenwriting?

Cutting my teeth as a film-maker, I wanted to test myself without falling back on dialogue. This is as hard at the script stage as the directing stage.

How quickly did you get to the first draft?

The treatment very quickly sprung into a first draft – the idea was fully structured in these earlier processes. Spending a long time on the idea meant I'd been through a lot of draft ideas and changes before I wrote anything.

I notice you use cards with scenes on them.

It helps organise my thoughts and move things around before starting to write. You can see what happens to the story like that.

And how did you develop your script into draft one and beyond?

I went through three initial drafts and then tried to impose things on it. I then went back to the initial draft. The process was then broken into two distinct drafts. The ending changed the most. Initially, it had a suspenseful ending, but the crew thought it would be better being lighter. I was urged to give it a try, but it made the ending something and nothing. I reined it back to its original tone.

How do you think an audience responded to your work when it was made and appeared on a screen?

Did the audience get it? The audience seems split down the middle about what happened. The fact that [the story] needed to be explained is a failing of the film. Endings are so important – especially with short films – films need to lead to[wards] that, otherwise [they] won't mean anything.

The ending works and people enjoyed the film, but being true to your original ideas can be the best way. If you change one thing it forces you to look back at everything you've written.

Snowed Under centres on a single character trapped in an office – trapped in more ways than one. With supernatural overtones, the film works as a metaphor for the experience of being constrained by circumstance.

Alisha McMahon > **James Condon** > Thomas Gladstone and Alexander Johnson

Feedback was essential – after a while you can't see the wood for the trees, especially when you don't have long to develop a script. I prefer more thinking time.

Thomas Gladstone (Tom): Writer *Put On Your Sunshine Boots* 2008
Alexander Johnson (Sandy): Producer/Script Editor *Put On Your Sunshine Boots* 2008

Tom is an avid writer and acted as writer and director of *Put On Your Sunshine Boots*. He followed this with similar work on a documentary. Tom continues to write and has a number of projects in development.

Sandy acted as Producer on *Put On Your Sunshine Boots* and also undertook script-editing duties, overseeing both conceptual and logistical issues with the script and its realisation as a film. In addition to producing, Sandy is skilled in sound and continues to work in both areas.

Where did your ideas come from?

Tom: From the image of 'den'; everyone can relate to that place where you play...particularly adults.

Sandy: That was the bit that got everyone going at the start, before the story had been fully developed. We knew it was a winner because people wanted to hear more when that was mentioned.

Tom: That was the bit that it was built around and everything stemmed from there.

Where in the process did you start writing?

Tom: I didn't bother with the log line but I had sort of summarised what the story was about. There were a number of points that needed to be covered by lots of log lines. I don't always see the need for them as a writer – [they're] more to sell the idea later.

Did following the conventional developmental process help you with structure?

Tom: I didn't really work on a treatment but used a step outline. It was a good way of getting ideas on paper and looking at whether they would work or not.

Sandy: The step outline was really useful – you could get a quick idea of the story and it helped a lot later when working with a crew.

Tom: I'm not sure the treatment helps the writer always as you know what's going to happen – as long as you don't forget.

How did you contend with dialogue – the hardest part of screenwriting?

Tom: Writing believable conversation was difficult. I was trying to get a lot across visually, but when you are dealing with detailed relationships things need to be said.

In helping with the development of the script, how did you go about aiding the drafting process?

Sandy: *Sunshine Boots* developed in subtle ways. Tom developed details to strengthen the relationships. That's when we started to work on logistics as part of the redrafting process.

Tom: It didn't change a lot from the first draft to be honest. The changes were quite subtle. I was always thinking 'how are we going to film this?' and that meant that a lot of things were worked out in advance.

Did feedback work for you?

Tom: Feedback was essential – after a while you can't see the wood for the trees, especially when you don't have long to develop a script. I prefer more thinking time.

Sandy: In the way we were working as a small short-film crew, it gave everyone ownership to give input to the ideas – even though Tom was very clear about the images he wanted right from the start.

What is going to happen to the film from here?

Tom: Well, we're going to send it out there.

Sandy: We are going to submit it to festivals and see how it will do.

Are you working on new material?

Tom: Yes, I've a few ideas kicking around and I'm developing those at the moment.

Sandy: I'm looking to work in sound while trying to sort out funding. In the end it's making it affordable.

Put On Your Sunshine Boots appears to be a romantic comedy on the surface, but works on a deeper level. It is a story about regaining a sense of childhood and the importance of play. At tho heart of the film is the building of a 'den' with a friend. This serves to make real the development of the central character.

James Condon > Thomas Gladstone and Alexander Johnson > Alexander Woodcock

I wrote the treatment for myself as well as the crew – it really broke it down and made me think of the pragmatics but it was also essential for the producer to examine the logistics and how it looked.

Alex Woodcock: Writer/Director *Without Wires* 2008

Alex is a keen screenwriter and researcher. These skills came together in the production of *Without Wires* – an ambitious script that Alex translated to the screen as director. Alex had two goals; the accurate portrayal of a particular period in history – Edwardian life and the experience of the trenches in the First World War – and the story of lost innocence. *Without Wires* is currently with a number of festivals and Alex continues working on a number of new script ideas.

Where did your ideas come from?

My idea came initially from period films about the First and Second World Wars and the depiction of authority figures. They normally focus on working-class figures and I wanted to see what would happen to an officer. It's far more interesting to see what would happen to the breakdown of someone in command.

This was still a big topic for a short film though.

Given the narrative, it was like picking memories – picking significant parts of their lives over four years. Like picking scenes from a feature without getting bogged down in too much detail. The film *was* big in idea. The challenge was to narrow it down and make it specific. Trying to explain the history but without being condescending because it was so obvious.

Did this take it too far from your sphere of knowledge?

Remembrance was a big influence on me. [It goes back] to the 1940s and [tells] a story – and if they can do it so can I. I did a hell of a lot of research.

But how do you make this subject matter real for an audience?
Generally speaking, people are more familiar with film than history.

I often watch films and don't agree with them. I'm interested in history and study a lot of history in my own time. The university context is familiar now, but [it wasn't] then in 1914; in addition the change in the role of women in society in less than 100 years [has been very dramatic].

Was a general knowledge of history enough?

I did extensive research into the First World War. You can get period stigma – an expectation of how characters will behave. What if the female character was more proactive and stronger? I look to history to find reasons why the characters behave in the way they do. To make it plausible. The internal conflict was the whole conflict in Europe. That's why Claire is Anglo-French and forms one half of the main relationship.

Thomas Gladstone and Alexander Johnson > Alexander Woodcock > Mark Herman

Did following the conventional developmental process help you with structure?

I wrote the treatment at the same time as developing the script. There were thematic issues so breaking it down to scenes was important. I wrote the treatment for myself as well as for the crew – it really broke it down and made me think of the pragmatics but it was also essential for the producer to examine the logistics and how it looked.

How useful did you find the step treatment?

The step treatment was to get a clear picture of the film in my head.

How did you prepare for your pitch?

The pitch was terrifying. The pitch I gave was too detailed. The pitch is to sell the film and I sold the story. The difference is important. I gave the narrative but ended on a cliffhanger. I should have made it less of a complete piece because it sounded too ambitious. The pragmatics were important and could have gone in. When people heard World War One they saw epic, Hollywood-esque and genre. It was difficult to come back from that. But it is different and I thought 'Screw them I'll go for what I want.'

Did these logistical issues ever stop you doing anything?

Not when I was writing. It was in the back of my mind and I thought 'What are people going to make of this?' But it was essential to get across what the story was about so it all had to be there. It was up to the producer to talk about what was possible later.

How did you contend with dialogue – the hardest part of screenwriting?

It is a classic love story in many ways, but it is what happens to the people concerned that is important – I wanted to show that but also wanted their voices to be heard.

I got a lot of feedback on the dialogue. It was hard writing in a way that people [actually speak] and making it understandable.

There is a tension between making something accurate to the period and making it 'filmic'.

Yes, but it is about being true to both.

How did your work develop between drafts?

Without Wires was a fully formed draft so the big changes were between the second and third draft when the logistics of the locations came in but also because some of them were anachronistic. The first draft was a series of ideas, the second was more specific, and after that you need to get what would have happened right.

How did you work with a script editor?

For feedback I turned to the producer. Producers are business people but they don't always instantly look to the money and not to the artistic.

Did the audience get it?

They seemed to. It worked as a war film and it worked as a love story and it worked as a historical film. A lot of people said they were amazed by the way that it looked. Not what you would normally expect to see in a short film.

Attention to detail in all aspects of the piece is evident in both the script and production of *Without Wires*.

No one can sit down and think 'I'll have an idea today' ... although that's what I've been trying to do this morning.

Mark Herman directing *Brassed Off* (1996)

Mark Herman is a writer and director who has worked in both shorts and features. His work has received public and critical acclaim across the world, including BAFTAs, Golden Globes and an Oscar. His films are: *See You At Wembley, Frankie Walsh* (1987), *Unusual Ground Floor Conversation* (1987), *Blame It on the Bellboy* (1992), *Brassed Off* (1996), *Little Voice* (1998), *Purely Belter* (2000), *Hope Springs* (2003) and *The Boy in the Striped Pyjamas* (2008).

Where does your inspiration come from?

It has been different every time. *Brassed Off*, as an example, came from driving through Grimethorpe from work (selling bacon) and seeing a place I knew that was now all different and thinking that I'd like to write a story about this. The rest of my films have been adaptations, apart from *Blame It on the Bellboy*: that came out of wanting to work out a difficult plot.

Did that start with an idea of genre or form or a particular story?

It was after seeing John Cleese interviewed about *Fawlty Towers* talking about how complicated plot lines could be. On that one, the longest time was [spent] writing the plot – a wall full of Post-it notes.

With *Brassed Off* you said you weren't looking for something; are you conscious of that when you start out writing?

After *Bellboy* was a flop, I spent a lot of time trying to write a hit. My agent said 'Forget trying to pay the bills and write about what you care about.'

But you can't sit down and think 'What do I care about?' It's quite by accident – there were road works on the A1 and I turned right. If they hadn't been there then... Once I thought there was a story, it was several weeks of working out what the story was. It was coincidental that the next day I was driving and heard a story on the radio about a brass band closing down in the North East. Until then, the brass band idea wasn't there at all.

So no methodology?

No, I'm not sure you *can* have one. No one can sit down and think 'I'll have an idea today'...although that's what I've been trying to do this morning.

When does character come in to it?

That's the next stage. With *Brassed Off,* it was to write a short treatment. In the end it bore no relation to the finished film, but it was enough to get the script financed. That had about six characters drawn out in full.

Alexander Woodcock > **Mark Herman**

**Blame It on the Bellboy
(dir: Mark Herman 1992)**

Herman's *Blame It on the Bellboy* is a classic comedy of errors,
played out by an all-star cast with hilarious consequences.

Do you have to use a log line?

No, but for *Brassed Off,* I sent Channel 4 a treatment and a tape of selected brass brand music of different, moving stuff. I went to Channel 4 for a meeting and stepped out of the lift to hear the music playing. I thought 'This is quite hopeful.'

Did you have to pitch the idea in that meeting?

They'd brought it to the stage of financing a first draft. The treatment was very short and sold a scenario and I had to expand on that.

Is the treatment a sales document?

The longer I've gone through my career, the more I think that and often it bears no relation to the finished film. I haven't had to do it since until *Floorshaker*. The treatment isn't that useful to me. I then do a private treatment for me, that will help me. I have a period when I write the story in text form to convince myself that it is a story and that it works.

That will reappear when it's down to marketing and those are quite similar, although I don't write the marketing. Once I've written the private treatment for myself I don't look back on it.

The longer you go on, [the less you] need the treatment... you are familiar with the form. A lot of great scriptwriters can't write treatments. The same is true of pitching – you have to act. Terence Davis will spend a great deal of time pitching, performing the actions as it's all in his head, whereas Terry Jones pitches like a stand up.

I was pitching *Bellboy* to a studio executive, sweating profusely (it's very intricate) and his phone rang. He answered it and gestured to me to carry on – I carried on while he took the phone call. At the end he said: 'I like the beginning and end but not the middle bit.'

After the treatment, you're a professional, and then you've got to make it better than that document.

Do you still use the Post-it notes system?

Or the old fashioned system of cards. I used it on *Bellboy*, *Brassed Off* and *Little Voice*. Perhaps because other stories are simpler. The function of the cards is to see whether you are spending enough time with the right people.

Do you ever use the three-act system or any other theory?

There are some that I've read and lectures I've been to and the more I think about it, the more I think 'You can't teach this.' At the time you start writing a script you aren't writing a script. You are thinking of stories that mean something to you.

It should never get too big for your head.

How important is watching films?

That's been my education – I went to film school but not for directing. That's where I've learnt what makes a good film and a good script.

Scriptwriting is not complicated and not about reaching page 27 and thinking, 'I must end Act One.'

Do you imagine yourself sat in the cinema?

I try and write films I'd like to see. Dialogue has to work realistically for me. I listen to people a lot about the bits that don't work.

How does that work with *The Boy in the Striped Pyjamas*?

A lot of that is to do with the music or rhythm of language. It's not to do with whether in the day they would say that, but to make it work. And to get the point across in the right way. The worst thing is when you can hear lines that are plot lines.

Characters saying what they feel is a nonsense.

With *Brassed Off*, I wrote the lines essential to the plot – not connected in any way – and then built the dialogue around that, far too much. Then you start hacking away.

When you've built up the lines of dialogue, you can separate them out. Then you might go back to a character and rewrite all their lines of dialogue in a way that they might say them.

This is redone when it's been cast and then again sometimes on the floor.

Do you work with character biogs?

I don't do that, but actors sometimes want it and sometimes actors want to do it themselves. With *The Boy in the Striped Pyjamas*, David [Thewlis] and Richard [Johnson] did that and they had it in their heads.

How many drafts do you work through?

Not a set number. For *The Boy in the Striped Pyjamas* – five, but they are very different. Within the drafts I make my own changes and then wait for weeks for the studio feedback. You'd be saying 'Can I try this?' and waiting for the feedback.

In drafts do you find yourself adding material in?

It's different every time. A lot of times, the people giving the feedback don't get the house of cards effect. What seems like a small tweak is a major change.

There are lots of people who read the script and it is difficult to please everyone. I get non-film people to read the script, and their feedback is very different, for obvious reasons.

Do logistics impact on writing the script or idea generation?

Yes, it does. As a director, I get angry with people telling me how it should be made – that's my job to decide. Writers shouldn't write what a director can't achieve. 'The sun glints off his worried brow ...' and why he's worried in one shot – it's unfilmable. They should find other ways to do that.

It's often to do with descriptions of feeling, that's where people make the mistake. They need to make it clear and to the point. Get across what you need to and set the scene.

In *The Boy in the Striped Pyjamas*, there are reams of description of Bruno being bored in the house. There isn't time to put all that in the film; I had to find a different way to do that so I put in a scene of him playing draughts with himself.

With *The Boy,* it is crying out for VO, but I hate it – the challenge is to do it without.

Tales of the bleedin' obvious – a lot of it is common sense.

Alexander Woodcock > **Mark Herman**

Brassed Off (dir: Mark Herman 1996)

On the set of *Brassed Off*, Mark Herman directs Pete
Postlethwaite in his role as Danny.

Alexander Woodcock > **Mark Herman**

So there you go. All the instructions you need for how to write the successful Hollywood blockbuster, and all for the reasonable price you paid for this book. Hang on, that's a different story.

What this text set out to do is to outline a process that already sits in place for today's screenwriter, indicate some industry expectations and provide a few things for you to consider when you embark on your screenplay. What Chapter 6 demonstrates is that there are as many differences in approach as there are similarities. You will find that there are no easy lessons or simple routes or even short cuts to writing a good screenplay.

What constitutes 'good' is down to the person listening to your pitch, or thinking of directing your work or, of course, the person sitting in the cinema staring at the flickering lights on the screen.

What is clear is that there are a number of qualities to be developed as you embark on a writing career:

Discipline	You need to find the ideas.
Consistency	A writer writes and you need to produce work.
Tenacity	Getting your work out there can be challenging.
Confidence	You might start to have doubts about your script the minute you start to pitch, but remember that producers can smell fear.
Memory	That overheard conversation in the pub or that treatment lining the bottom of the budgie's cage might be the next big hit.
Critical judgement	You may discover that the idea that you have spent three months sketching out might not be that good after all.
Observation	Real life is hard to imitate but it's where all the best stories come from.
Study	This might be reading (and judging) books on film, taking classes, talking to friends, watching a great deal or all of the above.
Persistence	Keep working through drafts, even when you find it necessary to make radical revisions.
Research	Swatting up for your script is essential. It's important that you research who you are pitching to or the appropriate person to send your script to.
Luck	The old adage about being in the right place at the right time is unfortunately true, but you can work on getting yourself nearer the right place and at the appropriate time.

As you start to develop your idea, spend some time working through the idea to make sure it works. This might be the Post-it notes on the wall or it might be writing a short story of the idea. Whichever method works for you, it helps before you spend a great deal of time on your script. If the story isn't right to start with, nothing you do will fix it later. Take confidence in knowing that you know the form you are writing for.

Be ruthless with yourself. The biggest trap writers fall into is sticking with the initial idea and being unwilling to change draft one beyond tinkering. It is a rare script that works at draft one. Are you telling the right person's story? Are you telling the story in the most appropriate way? After all, you don't want your work to be good; you want it to be absolutely great.

Listen to criticism. This can be tough, particularly when you have poured your heart and soul on to paper. Sometimes the critic or the script reader might be talking nonsense. When you move to bigger-budget work, you'll have feedback from more than one person at the same time and it will invariably be contradictory, but you'll nevertheless need to evaluate it and consider it.

Writing can be difficult, frustrating, solitary and maddening, but it can also be the most rewarding experience of all.

Without a screenwriter – without you – film would simply not exist.

So, stop reading this and start writing... now.

Character biography
A device often used by writers to outline the back story of a character. Sometimes used by directors in working with actors.

Character motivation
The rationale for character behaviour. This is normally logical behavioural traits.

Christian Metz (1931-1993) French film theorist and semiotician. His book *Film Language* has been hugely successful for its examination of film structure.

Cinematographer
(sometimes known as the Director of Photography/ DoP) This member of the film-making team is head of lighting and camera and is responsible for the film's aesthetic, working alongside the director.

Closure
The term applied to the end of a film where there is clear resolution with all (or most) loose ends tied up.

Dialogue
The written form of speech intended as speech for characters and/or to be used as a voice-over.

Diegetic
From the Ancient Greek 'diegesis', meaning story. This refers to that which is within the 'real world' of the created story world.

Editor
Works as head of the post-production crew. They edit shots and often sound alongside the director.

Expository dialogue
This is dialogue that is descriptive and serves only to fill in gaps or to explain a story that is too complex.

Feature films
Normally 90 minutes or more in length and often characterised by more locations, characters and particularly subplots. They are usually intended for cinema release.

Genre
The name given to the characteristics, stories and/ or aesthetics that link films (often of different countries and different periods).

Log line
Refers to a short summary of the narrative of the script and normally intended to sell the idea.

Mise en scène
Means 'within the frame' and refers to everything that can be seen on the screen.

Narration
Speech – which can be from characters we see or as a voice-over from a character we may never see or meet.

Narrative
The act of structured communication. Narrative is often used in the same way as story, but it is also about how the detail of the story is structured, how it communicates and thus has meaning to an audience.

Narratology
A body of theory that examines and analyses narrative structures primarily in terms of form but also in terms of content.

Non-diegetic
Refers to that which sits outside the created world of the story, for example dramatic sound effects.

Pitch
This is the (normally) verbal presentation of the story concept in order to gather interest either for development funding or to sell the idea.

Plot
The aspect of the narrative that provides interest. It is more than what happens – it is why things happen – and drives the relationship from one event to the next.

Point-of-view
The perspective from which the story is judged. Normally from the vantage point of the main protagonist.

Portmanteau film
A film that consists of a series of shorter films, often related by theme or genre and related by a consistent overarching story.

Producer
The individual who is with the film from the start of the process. The producer's primary concern is finance – and with that goes logistics. At the start of the process of film-making, the producer is responsible for selecting key members of the crew and at the end of the process is responsible for distribution. Producers will often be the first significant industry professionals to read over your script.

Roland Barthes (1915-1980)
French semiotician. His work influenced the development of theories of structure and allowed popular forms, such as film, to be included in academic study.

Screenplay
This is the alternative term for film script, often used for television scripts.

SFX
Shorthand for sound effects, normally added to film in the post-production phase.

Shooting script
The final script as marked and ready for filming.

Short films
Normally 15 minutes or less. They are usually intended for festival screening rather than mass distribution. The criteria of the festival or the funding agency will often dictate length and sometimes form and content.

Step treatments
Often called step outlines, this is a more detailed form of the treatment, that breaks down the structure and causal relationships of the story idea.

Structuralism
The name given to a grouping of theorists and theories that analyse how various media (including film) are structured and how they communicate. It is an umbrella terms that covers a range of subsets, including Narratology.

Subtext
Meaning that which is not at the forefront of speech; hidden meaning that is intended to be understood with careful reference.

Syd Field:
An American writer and film consultant. His book *Screenplay*, published in 1979, has been highly influential in expounding and popularising the three-act structure.

Teaser Trailer
The term applied to a short trailer that is used to sell a film in advance of a main advertising trailer closer to release. It is also applied to a trailer that is created to sell a concept – to show what a film might look like if it were given funding.

Treatments
Short prose summaries of the script idea normally intended to gain interest and to sell.

Voice-over
The voice which is heard over the story most often commenting on what is seen or heard. Most commonly heard in film noir. This voice is usually a character within the film.

FIRST DRAFT

SECOND DRAFT

A NICE CUP OF TEA

Writing a script is a difficult business, whether you are a novice or a seasoned professional. We thought it would be a good idea to include a sample working script within the pages of this book to emulate what a script might look like at the three crucial stages of its inception; the tricky first draft, the revised second draft and the all-important final draft.

In Chapter 3, we helped you to get started – from making your first mark on the paper to producing a complete draft of your screenplay. In Chapters 4 and 5, we showed you how to refine your initial draft, by illustrating how *A Nice Cup of Tea* could be successfully edited into a more manageable – and therefore marketable – script.

The script pages within the book are numbered within each chapter, so you can navigate them easily, while reading them against the main points designed to help you develop your script step-by-step. The final version of the script is very different to the first; so to make comparison between the different drafts easier, we reproduced them here in full. Read them from start to finish as you work your way through the book, and observe the overall combined effect of the changes both on the shape and content of the script.

Watch out for variations in minor details across the different scripts, as well as for more significant structural edits. What would you change if *A Nice Cup of Tea* were your own screenplay?

INT. KITCHEN. HOUSE. DAY.

It's cramped and rather shabby. Two CHILDREN, JAMES aged 11 and DENISE aged
9, sit at a square table. CHRISTINE stands by the sink washing up in a
desultory fashion. She's in her mid thirties. She doesn't look very happy.

Enter KEITH UNDERWOOD. He's late thirties, harassed looking. He's obviously
running late and he isn't very happy either, but fixes a smile on his face.

 KEITH
 Good morning all.

They all ignore him. Keith goes to a work surface. There is a teapot under a
tea cosy. He looks at the plates in the sink.

 KEITH
 Breakfast?

 CHRISTINE
 We're out of bacon. The kids had the last of
 the cornflakes.

She is daring him to fight back. He controls himself.

 KEITH
 Right. Fine, I'll just have a nice cup of tea.

He takes the tea cosy off the pot. Finds a cup and saucer.

 KEITH
 Tea. That's all I need to set me up for the day.

He lifts the tea cosy, touches the pot, and yes – it's hot. He adjusts the
cup and saucer, puts the strainer in place and slowly tips the pot. The tea
is hopelessly weak, the colour of peat bog water. His face falls.

 KEITH
 For Christ's sake...

 CHRISTINE
 Language.

 KEITH
 You've only put in one spoonful of tea. Why do
 you always do that?

They talk across each other. This is an old argument.

 CHRISTINE
 You're the only one that drinks tea...
 KEITH
 One spoonful for each person and one for
 the pot...

 CHRISTINE
 ...and you never drink more than one cup.

 KEITH
 ...freshly boiled water, and let it stand
 for five minutes. Is that so hard?

 CHRISTINE
 , It's a waste.

 KEITH
 Tea's cheap. We can afford tea.

 CHRISTINE
 On what you bring home we can't afford
 anything.

 KEITH
 Except bingo...oh, and cinema tickets.

He grabs at the pot and flings its contents into the sink.

 KEITH
 I'll make it myself.

Then he starts looking for the tea, opening cupboards. Christine stands
back, arms folded. James and Denise look faintly bored. Keith is about to
crack and ask Christine where it is. But he sees the kitchen clock. It says
twenty past eight.

Keith looks at his cheap looking watch. It says five past eight. He taps it.
It's stopped. This is very bad news.

Christine looks at her watch. It's much nicer than Keith's. Smiles.

 CHRISTINE
 I make it twenty past, too.
 (a beat)
 What time's your train?

EXT. HOUSE. STREET. DAY

It's raining hard. As Keith hurries down the drive he passes his neighbour
RICHARD, he's about the same age but far more self assured; he's also tall,
handsome and owns a car.

He's opening the driver's side door. He has an impressive-looking vacuum
flask under his arm.

> RICHARD
> (complacent)
> Horrible weather.

> KEITH
> Yes. Can't stop. Train.

> RICHARD
> Trains? Never again. Want to get yourself
> one of these.

He grins. Keith scurries off into the rain.

EXT. RAILWAY STATION. DAY.

There's a small hatch behind which a **WOMAN** is serving drinks. It's crowded.
Keith has one person in front of him. The tannoy crackles. It's echoey and
largely incomprehensible.

> TANNOY
> Mumble...8.31...mumble...now...mumble...
> platform two...

The woman is pouring tea from a huge metal teapot. She serves the **MAN** at the
head of the queue. He's very slow in finding change. Keith is almost dancing
with frustration. A train pulls in. We hear the doors opening. The Man is
still fumbling with his change. Finally he pays. Keith makes it to the
counter.

> KEITH
> Tea please.

The Woman tips the teapot. Keith turns briefly to see the commuters boarding
the train. Come on. Come on. The teapot tips further and further - now the
spout is pointing straight down. But it's empty. The Woman grimaces. Keith
is devastated. He turns and runs for the train.

INT. TRAIN. CARRIAGE. DAY.

It's packed, almost too crowded to move. Keith is wedged in near to the
doorway between two carriages. If he stands on tiptoes he can just see the
buffet car. But he can't get to it, he struggles a little but it's no use.
He's not going to make it - it will remain out of reach.

INT. FOYER. OFFICE BUILDING. DAY.

It's four minutes past nine. The foyer possesses that quality of echoing
emptiness that always makes the late arrival feel highly conspicuous.
Two RECEPTIONISTS look at him with a mix of pity and interest, like watching
a condemned man on his way to the gallows.

INT. OFFICE. DAY.

There are two rows of desks. All occupied, bar one. Keith enters, several
people look up. His eyes flit to a glassed off Inner Office. He sees the
door's shut. Looks relieved. Hurries across the unoccupied desk. Sits,
snatches papers from his in-tray.

 DISSOLVE TO LATER

The pile of papers in the in-tray has diminished. The pile in the out-
tray has increased. The clock is ticking towards 10.45. Keith massages his
temples, winces and then rubs sore eyes. He looks at the clock longingly.
The minute hand touches the nine.

The door opens. A **TEA LADY** enters, pushing a tea trolley. The tea lady,
Denise, is friendly, slightly plump and not unattractive.

Keith's desk is nearest the door. She comes to him first.

 KEITH
 Denise, even if that pot was empty, you'd still
 be the best part of my morning.

 DENISE
 It is empty.

 KEITH
 I don't care.
 (a beat)
 It's not...

 DENISE
 Of course not.

She lifts the teapot.

 DENISE
 Freshly boiled water, warm the pot, brew for
 five minutes, tea in first.

She pours the tea, picks up the milk jug. The cup is filled. She places it
on a saucer and hands it to him. He stares at it, catches the aroma and is
about to drink when...

The door of the Inner Office swings open. **HARRIS**, Keith's boss, stands in
the doorway. He's big, handsome, about forty. Alpha Male. He bellows:

 HARRIS
 Underwood! In here. Now!

Keith hesitates for a second. Looking at the tea.

 HARRIS
 Leave that! I said now!

Defeated, he puts his cup on the desk.

INT. INNER OFFICE. DAY.

We are looking down from a high corner. Keith sits huddled in on himself,
like prey, as Harris circles, verbally battering him and drinking a cup
of tea. We hear the slurping as he drinks his tea. He picks up a sheaf of
papers, stapled together, with his free hand.

> HARRIS
> Sloppiness, Underwood, sloppiness up with which
> I will not put.

He drinks some tea. Keith's eyes follow every movement, longingly.

> HARRIS
> Just like lateness. I don't put up with
> lateness. So someone who is late and sloppy had
> better hope I never find out. But of course I
> do find out. Always.

Keith raises his head a fraction.

> KEITH
> But Mr. Harris...

> HARRIS
> Do not interrupt me. You know what this is?

He places the paper on the desk in front of Keith, takes out a pen and
writes three letters - N. B. G, large and bold. As he does so, Keith can
smell the tea, can see it only a few inches from his mouth - but it's
utterly unobtainable.

> HARRIS
> It's three letters - N.B.G. No bloody good. Not
> acceptable. And do you know what you're going
> to do about it? I'll tell you. You're going to
> do a home visit. Now.

> KEITH
> Now?

> HARRIS
> Yes. As in get out of my office, put on your
> coat and go. Now.

EXT. OFFICE BLOCK. DAY.

The main entrance. Keith hurries in looking even more weary.

INT. OFFICE BLOCK. FOYER. DAY.

The big clock reads three minutes to two. The lift doors are open as Keith
hares across the foyer to the lift. The doors shut just as he reaches them.
He runs for the stairs.

INT. OFFICE BLOCK. FOYER. SIXTH FLOOR. DAY.

It is open and empty. There are two flights of stairs on either side of the lift shaft. Keith stumbles up the left hand one, gasping for breath. The clock on the wall above twin sets of double doors reads one minute to two. He staggers across the foyer and virtually throws himself through the left hand doors into:

INT. CANTEEN. OFFICE BLOCK. DAY.

It's large and virtually deserted. About half a dozen late diners are just finishing up. The canteen is a 'collect your tray and move along' arrangement. The serving area occupies an entire wall of the canteen, with the kitchens behind. There are rails in front of it to corral the customers.

Keith pays no attention to the **KITCHEN HANDS** who are emptying and scraping the trays that contained the food. His glance goes straight to the area by the till. The hot drinks area. He dashes for the start of the rails and almost runs along as the shutters come down in an almost synchronised fashion.

Each one shuts just as he reaches that section of the serving area. Despairingly he watches as a WOMAN reaches for the shutter that will keep Keith from his goal...

 KEITH
 No!!!!

But too late. The shutter comes down. Enraged, Keith hammers on it.

 KEITH
 I only want a cup of tea.

INT. OFFICE. DAY.

Keith is working. We go in close on the clock. And see the big hand touch the twelve.

Keith puts his pen down, checks his watch. The door opens. Denise enters. Keith lets out a sigh of relief. He smiles at her. She smiles back. He's about to say something when the door of Harris's office opens. Harris steps out.

 HARRIS
 Miss Sutton - a word.
 (a beat)
 And a tea, if you please.

Denise smiles apologetically. She pours a tea and takes it into Harris's office. The door closes. There is a general frisson of disquiet round the office - but no-one quite knows what to say.

It is as though time has frozen.

The clock is now at ten past. There is now a definite restlessness in the office.

 WORKER #1
 It'll be stewed

 WORKER #2
 Or cold

 WORKER #3
 A word. A *word*.

Keith suddenly decides he must do something. He stands up, pushes his chair
back. Walks towards Harris's office. Raises his hand to knock, thinks better
of it. Then courage returns. He raps on the door. There's no answer.

 KEITH
 Mr. Harris...

He looks at the tea trolley. Raises his hand to knock again. Instead he
grasps the handle and walks straight into:

INT. HARRIS' OFFICE. DAY.

There is a cup of tea on the desk. But this is not the first thing Keith
notices. Or us. Technically speaking, Denise and Harris aren't actually
having sex, but they're as close as makes no difference. Keith is appalled.

 KEITH
 Denise!

They spring apart. Denise gasps and starts trying to make herself decent.
Harris looks embarrassed but angry.

 HARRIS
 Underwood! How dare you!

But Keith is angry too. He picks up the cup of tea and flings the contents
all over Harris.

INT. FOYER. OFFICE BLOCK. DAY.

Keith is being escorted from the building by two uniformed **COMMISSIONAIRES**.
He is clutching his briefcase and, in the other hand, a brown envelope and
various bits of paper.
As he passes the reception desk the **RECEPTIONISTS** look at him with vague
sympathy. They are both drinking tea.

EXT. STREET. CITY. DAY.

Keith is walking along looking somewhat dazed and at a loss. He passes a
very expensive looking café with a snooty looking **MAÎTRE D'** at the door. In
the road, a gang of **WORKMEN** are using a pneumatic drill. It yammers into
life. Keith winces. His headache is still bad. Then he looks at the café. He
opens his brown envelope. There's quite a lot of cash inside. He turns back.

EXT. CAFÉ ENTRANCE. DAY.

He passes the Maître d' and, airily, flips him a coin.

INT. CAFÉ. DAY.

It's very classy. Keith is seated towards the rear. We can still just hear
the occasional staccato bursts from the pneumatic drill but that's not
bothering Keith over-much. He's concentrating on the little tea ceremony
that is being performed in front of him. A very neatly uniformed **WAITRESS** is
about to pour him tea.

This is a truly impressive tea service; the business. The cup is placed on a
saucer in front of Keith. The Waitress lifts the teapot. The pneumatic drill
stutters and there is a very loud **BANG**.

This is followed by a flash of blue light. All the lights go out.
The Waitress screams, tips the teapot - over Keith's crotch.

Keith yells. There are cries of alarm. Then the Maître d' shouts:

 MAÎTRE D'
 Mesdames, monsieurs - I am sorry but I must ask
 you all to leave...

INT. TRAIN. DAY.

This train has a small on-board buffet. It's busy, but not too crowded.
There are about eight or nine customers. Keith is second in the queue.
There is a **FAT MAN**, a business type, in front of him, taking a cup of
tea from the **STEWARD**.

 FAT MAN
 Thank you.

 STEWARD
 (to Keith)
 Yes sir.

 KEITH
 Tea please.

 STEWARD
 Yes sir.

He lifts up the teapot to pour it. But...

The Fat Man cries out in pain and alarm, drops his tea, clutches his chest
and pitches forward. Everyone is stunned, but Keith recovers first.

 STEWARD
 My God...it must be his heart.

 KEITH
 (coldly)
 Yes. You were about to pour me a cup of tea.

The Steward looks at him disbelievingly.

 STEWARD
 I'm in the St. John's ambulance.

He pushes open the half doorway and steps out.

 STEWARD
 Excuse me.

Immediately everyone is focused on the Steward as he starts to try to help.
Everyone except Keith. He's had enough. He steps behind the counter and
pours himself a tea. In a mug. It looks good. He lifts it to his lips. Just
as one of the group round the stricken fatty turns round and, on a nod from
the steward, pulls the communication cord. The train brakes sharply.

The mug flies from Keith's hand. The teapot crashes to the floor.

EXT. HOUSE. STREET. DAY.

Keith walks back to his front door, he looks almost broken.

He opens the front door.

INT. KITCHEN. DAY.

Keith is writing a note. It reads:

'*Home early. Terrible headache. Gone upstairs for a lie down with a nice cup
of tea.*'

He picks up a cup of tea.

EXT. LANDING. DAY.

Keith looks down at the tea and manages a half smile. Almost there. He opens
the door of the bedroom.

INT. BEDROOM. DAY.

Christine is in bed with Richard. They both sit up gobsmacked. Keith is
utterly stunned.

 KEITH
 Christine!

He drops the teacup, we follow its fall in slo-mo. As it hits and slashes we
go straight to a violent flash of white light.

ON WHITE

INT. A ROOM. DAY.

There's a lot of white and details resolve out of it. A snow-white
tablecloth. A silver tray with things for tea laid on it. A white teapot, a
white milk jug, a beautiful and capacious white china cup on a white saucer.
The scene has a slightly surreal burnish to it.

A MAN, grave and dignified, white gloved picks up the teapot and pours.

 MAN
 The water was freshly drawn, the pot was
 warmed, the tea has been brewed for exactly
 five minutes. The milk is fresh.

He pours the milk. He pours the tea and passes the cup to Keith. Keith is
framed against a white background.

 MAN
 There you go Mr Underwood, a nice cup of tea.

Keith picks up the cup, studies the colour, inhales the aroma. Then,
tentatively, takes a sip. It is a beautiful cup of tea. Perfect. He gives
a beatific smile. He nods slightly. The Man acknowledges his nod with a
satisfied, duty-done nod of his own.

Keith drinks the tea. He puts the cup down. Smiles.

 KEITH
 Tea. That's all I need to start the day.

He stands. Instantly two **UNIFORMED MEN** move in on both sides and pinion his
arms behind his back.

The folded handkerchief that the MAN whips out of his front pocket is a **HOOD**
And a door to the side to the side of the table swings open.
Revealing the **GALLOWS.**

SNAP TO BLACK

MUSIC: I Like a Nice Cup of Tea

SECOND DRAFT

EXT. STREET. DAY

A suburb. A row of thirties suburban semis. A dull ordinary morning on a
dull ordinary day.

 DISSOLVE TO:

INT. KITCHEN. HOUSE. DAY.

It is sometime in the nineteen fifties.

The kitchen is cramped and rather shabby. Two children, a boy and a girl:
JAMES aged 11 and **JACKIE** aged 9, sit at a square table. The table is covered
with a chequered red and white plastic tablecloth. **CHRISTINE** stands by
the sink washing up in a desultory fashion. She's in her mid thirties,
attractive but unhappy, very unhappy and made more so by the entrance of:

KEITH UNDERWOOD - our hero. He's late thirties, harassed-looking and has
a bad shaving cut on his chin plugged with bloodied tissue paper. He's
obviously running late and he isn't very happy either.

Everyone ignores him. Keith goes to a work surface. There is a teapot under
a tea cosy. He looks at a plate on the surface next to the sink. There is a
bacon rind on it. He picks it up like he's a forensic scientist with a vital
piece of evidence. He looks at Christine. She stares back, daring him to
complain. He controls himself.

He picks up a packet of cornflakes from the table. Picks up a bowl. Tips up
the packet. One cornflake falls out. Keith takes a deep breath.

Finds a cup and saucer and his actions become almost ritualistic. He lifts
the tea cosy, touches the pot, and yes - it's hot. He adjusts the cup and
saucer, puts the strainer in place and slowly tips the pot. The tea is
hopelessly weak, the colour of peat bog water. His face falls.

He takes the pot and flings its contents into the sink. Then he starts
looking for the tea, opening cupboards. Christine stands back, arms folded.
James and Jackie look faintly bored. Keith is about to crack and ask
Christine where the tea is. But he sees the kitchen clock. It says twenty
past eight.

Keith looks at his cheap-looking watch. It says five past eight. He taps it.
It's stopped. This is very bad news.

Christine looks at her watch. It's much nicer than Keith's. Smiles.

EXT. HOUSE. STREET. DAY.

It's raining hard. As Keith hurries down the drive, he passes his neighbour **RICHARD**, who's about the same age but far more self assured; he's also tall, handsome and owns a car. He's opening the driver's side door. He has an impressive looking vacuum flask under his arm.

He grins as Keith scurries off into the rain. Gets into the car.

EXT. RAILWAY STATION. DAY.

There's a small hatch behind which a **WOMAN** is serving drinks. Keith has one person in front of him. The tannoy crackles. It's echoey and largely incomprehensible.

The woman is pouring tea from a huge metal teapot. She serves the **MAN** at the head of the queue. He's very slow in finding change. Keith is almost dancing with frustration. A train pulls in. We hear the doors opening. The Man is still fumbling with his change. Finally he pays. Keith makes it to the counter.

The Woman tips the teapot. Keith turns briefly to see the commuters boarding the train. Come on. Come on. The teapot tips further and further - now the spout is pointing straight down. But it's empty. The Woman grimaces. Keith looks deeply frustrated. Behind him a whistle blows - he turns and runs for the train.

EXT. OFFICE BLOCK. DAY.

We see Keith hurry up the steps to the entrance.

INT. FOYER. OFFICE BUILDING. DAY.

It's four minutes past nine. The foyer possesses that quality of echoing emptiness that always makes the late arrival feel highly conspicuous. Two RECEPTIONISTS look at him with a mix of pity and interest, like watching a condemned man on his way to the gallows.

INT. OFFICE. DAY.

There are two rows of desks. All occupied, bar one. Keith enters, several
people look up. His eyes flit to a glassed off inner office. He sees the
door's shut. Looks relieved. Hurries across to the unoccupied desk. Sits,
snatches papers from his in-tray.

 DISSOLVE TO LATER

The pile of papers in the in-tray has diminished. The pile in the out-
tray has increased. The clock is ticking towards 10.45. Keith massages his
temples, winces and then rubs sore eyes. He looks at the clock longingly.
The minute hand touches the nine.
The door opens. **A TEA LADY** enters, pushing a tea trolley. A vision in white
and silver. The light becomes warmer – as though the sun has just come out.

The tea lady, Denise, is also quite eye-catching. She's younger than you
might expect, dark haired, pretty. Keith smiles at her. And at the large
teapot. Keith's desk is nearest. She comes to him first.

He looks at her, smitten. She lifts the teapot.

She pours the tea, picks up the milk jug. The cup is filled. She places it
on a saucer and hands it to him. He stares at it, catches the aroma and is
about to drink when...

The door of the inner office swings open. **HARRIS**, Keith's boss, stands in
the doorway. He's big, handsome, about forty. Alpha Male. He points a finger
at Keith. Beckons menacingly.
Keith hesitates for a second. Looking at the tea. Harris shakes his head.
Defeated, Keith puts his cup on the desk

INT. INNER OFFICE. DAY.

We are looking down from a high corner. Keith sits huddled in on himself,
like prey, as Harris circles, drinking a cup of tea.

Keith's headache is now thudding on the soundtrack. We hear the slurping as
Harris drinks his tea. He picks up a sheaf of papers, stapled together, with
his free hand.

He drinks more tea. Keith' eyes follow every movement, longingly.

Keith raises his head a fraction, fingers to his temples. A distant rhythmic thud is heard. Keith has a headache. A bad one.

Harris slams the paper on the desk in front of Keith, takes out a pen and writes three words: **MUST DO BETTER**, large and bold. As he does so Keith can smell the tea, can see it only a few inches from his mouth - but it's utterly unobtainable.

 CUT TO:

Keith is putting on his overcoat. A COLLEAGUE looks at him and at the cup of tea on his desk. Harris is watching. A little pantomime is performed. The Colleague gestures at the tea, raises his eyebrows in enquiry. Slowly and with infinite sadness, Keith shakes his head. The Colleague takes the tea. Sips. It's a good brew.

INT. CLOSE UP. DAY.

Keith is seated on a vile greenish-yellow sofa, it's scuffed and filthy. Keith looks very hot. He is sweating, almost panting. An elderly woman is complaining, pointing at papers on her lap and gesticulating.

The room is small and cramped. The **ELDERLY WOMAN** is in her early seventies and none too hygienic-looking. We note a chamber pot tucked under the chair she sits in. We see a fire, blazing. And we see the **CATS**. There are almost too many to count. They cover every spare surface. And they're malevolent-looking cats that plainly add to the smell.
Keith is sickened by the sight of a cat openly urinating in a corner.
It isn't discreet. You can *hear* it.

The Elderly Woman follows Keith's horrified, open-mouthed gaze. It doesn't faze her over-much. She shakes her head indulgently, gets up and shuffles out of the room.

 CUT TO

The Elderly Woman is passing him a cup. But it's from a tray with a filthy looking and chipped teapot, a half-empty milk bottle and a sugar bowl full of tea-stained clumps of sugar. As for the cup he's being handed...

It may be china, but it's very hard to tell; the rim is too furry, plastered with cat hairs. He tentatively wipes part of the rim, hairs mat on his fingertip. No. He can't. He blows on it to gain time.

She smiles encouragingly. Keith gives a sickly smile. But he's saved by another cat, a large black beast which has learnt by example; it urinates loudly in a corner. The Elderly Woman turns to look.

Keith seizes his chance. He tips the tea into a plant pot

EXT. OFFICE BLOCK. DAY.

The main entrance. Keith hurries in.

INT. OFFICE BLOCK. FOYER. DAY.

The big clock reads three minutes to two. The lift doors are open as Keith hares across the foyer to the lift. The doors shut just as he reaches them. He runs for the stairs.

INT. OFFICE BLOCK. FOYER. SIXTH FLOOR. DAY.

It is open and empty. There are two flights of stairs on either side of the lift shaft. Keith stumbles up the left hand one, gasping for breath. The clock on the wall above twin-sets of double doors reads one minute to two. He staggers across the foyer and virtually throws himself through the left hand doors into:

INT. CANTEEN. OFFICE BLOCK. DAY

It's large and virtually deserted. About half a dozen late diners are just finishing up. The canteen is a 'collect your tray and move along' arrangement. The serving area occupies an entire wall of the canteen, with the kitchens behind. There are rails in front of it to corral the customers.

Keith pays no attention to the **kitchen hands** who are emptying and scraping the trays that contained the food. His glance goes straight to the area by the till. The hot drinks area. He dashes for the start of the rails and virtually runs along as the shutters come down in an almost synchronised fashion.

Each one shuts just as he reaches that section of the serving area. Despairingly, he watches as a **WOMAN** reaches for the shutter that will keep Keith from his goal...

But too late. The shutter comes down. Enraged, Keith hammers on it.
No response. Keith raises his fist to hammer again, but thinks better of it.
His shoulders slump. He walks away.

INT. OFFICE. DAY.

Keith is working. He has a headache. A very bad headache. Everything seems
extra noisy. He stops to hold his head in his hands. He looks up at the
clock. It's a couple of minutes to three.

He resumes work.

We go in close on the clock. And see the big hand touch the twelve.

Keith puts his pen down, checks his watch. The door opens. Denise enters.
Keith lets out a sigh of relief. He smiles at her. She smiles back. He's
about to say something when the door of Harris's office opens. Harris steps
out. Beckons to her.

Denise smiles apologetically at Keith. She pours a tea and takes it into
Harris's office. The door closes. There is a general frisson of disquiet
round the office – but no-one quite knows what to say.

It is as though time has frozen.

 DISSOLVE TO:

The clock is now at ten past. There is a definite restlessness in
the office.

Keith's headache is plainly excruciating. Suddenly, he decides he must do
something. He stands up, pushes her chair back. Walks towards Harris's
office. Raises his hand to knock, thinks better of it. Then courage returns.
He raps on the door. There's no answer.

He looks at the tea trolley. Raises his hand to knock again. Instead he
grasps the handle and walks straight into:

INT. HARRIS' OFFICE. DAY.

There is a cup of tea on the desk. But this is not the first thing Keith notices. Or us. Technically speaking, Denise and Harris aren't actually having sex, but they're as close as makes no difference. Keith is appalled.

They spring apart. Denise gasps and starts trying to make herself decent. Harris looks embarrassed but angry.

But Keith is angry too. He picks up the cup of tea and flings the contents all over Harris.

INT. FOYER. OFFICE BLOCK. DAY.

Keith is being escorted from the building by two uniformed **COMMISSIONAIRES**. He is clutching his briefcase and, in the other hand, a brown envelope and various bits of paper.

As he passes the reception desk, the **RECEPTIONISTS** look at him with vague sympathy. They are both drinking tea.

EXT. STREET. CITY. DAY.

Keith is walking along looking somewhat dazed. He passes a very expensive-looking café with a snooty looking **MAÎTRE D'** at the door. In the road, a gang of **WORKMEN** are using a pneumatic drill. It yammers into life. Keith winces. His headache is still bad. Then he looks at the café. He opens his brown envelope. There's quite a lot of cash inside. He turns back.

EXT. CAFÉ ENTRANCE. DAY.

He passes the Maître d' and, airily, flips him a coin.

INT. CAFÉ. DAY.

It's very classy. Keith is seated towards the rear. We can still just hear the occasional staccato bursts from the pneumatic drill but that's not bothering Keith over-much. He's concentrating on the little tea ceremony that is being performed in front of him. A very neatly uniformed **waitress** is about to pour him tea.

This is a truly impressive tea service; the business. The cup is placed on a saucer in front of Keith. The Waitress lifts the teapot. The pneumatic drill stutters and there is a very loud **BANG**.

This is followed by a flash of blue light. All the lights go out.
The Waitress screams, tips the teapot – over Keith's crotch.

EXT. STREET. CITY. DAY.

It's still raining. Keith hurries along the street. And turns into the entrance of a RAILWAY STATION.

INT. STATION BUFFET. DAY.

It's busy, but there are a couple of tables free. The place is self service. He takes a tray and slides it along the counter until he reaches the point at which hot drinks are served. A bored-looking girl of about eighteen stands there. Eventually she notices Keith.

She picks up a pot, picks up a stainless steel infuser on a chain and puts it in the pot. The she manoeuvres the pot under the spout that spits out boiling water.

The Girl blasts boiling water into the pot. Puts the pot, a cup and saucer, a bowl of sugar and a small jug of milk on the tray.

DISSOLVE TO:

Keith sitting at a table. He's waiting for the tea to brew. He touches the pot. Looks at his watch. He rubs his hands in anticipation.

Looks at his watch. Drums his fingers. Then notices a sudden in-rush of customers. Looks at his watch again.

He picks up the pot and pours the tea. It's a rich golden brown. Keith's nostrils twitch. It's perfect. He relaxes. At last. He picks up the milk jug. Pours the milk, a pure stream of white. Only it's not. It curdles.

He looks at it with disbelief. Then anger. He picks the tray up and heads towards the counter. But it's now very busy.

He tries to attract the girl's attention but there's a press of customers at the counter. She ignores him.

He puts the tray down on a trolley. And dejected but hurried, heads out onto the platform.

INT. BUFFET CAR. TRAIN. DAY.

It's busy, but not too crowded. There are about eight or nine customers.
Keith is second in the queue. There is a **FAT MAN** – a business type, in front
of him, taking a cup of tea from the **STEWARD.**

He lifts up the teapot to pour a tea for Keith it. But...

The Fat Man cries out in pain and alarm, drops his tea, clutches his chest
and pitches forward. Everyone is stunned, but the Steward recovers fast. He
pushes open the half doorway and steps out.

Immediately everyone is focused on the Steward as he starts to try to help.
Everyone except Keith. He's had enough.

He steps behind the counter and pours himself a tea. In a mug. It looks
good. He lifts it to his lips just as one of the group round the stricken
fatty turns round and – on a nod from the Steward – pulls the communication
cord. The train brakes sharply.

The mug flies from Keith's hand. The teapot crashes to the floor.

EXT. HOUSE. STREET. DAY.

Keith walks back to his front door. He looks almost broken. A car is heard
passing; he winces. His headache is killing him.

He opens the front door.

INT. KITCHEN. DAY.

Keith is writing a note. It reads:

'Home early. Gone upstairs for a lie down with a nice cup of tea.'

He then shakes a couple of aspirin out of a bottle, puts them in his mouth,
washes the down with a glass of water.

He picks up a cup of tea.

INT. BEDROOM. DAY.

Keith enters. Christine is in bed with Richard. They both sit up gobsmacked.
Keith is utterly stunned.

He drops the teacup; we follow its fall in slo-mo. As it hits and splashes,
we go straight to a violent flash of white light.

ON WHITE

INT. A ROOM. DAY.

It's white and details resolve out of it. A snow-white tablecloth. A silver
tray with tea things laid on it. A white teapot, a white milk jug, a
beautiful and capacious white china cup on a white saucer. The scene has a
slightly surreal burnish to it.

A MAN, grave and dignified, looking like a high-grade butler and wearing
white gloves picks up the teapot and pours.
A golden stream of tea arcs into the cup. Then he pours the milk and passes
the cup to Keith. Keith is framed against a white background.

 BUTLER
 There you go, Mr. Underwood,
 a nice cup of tea.

Keith picks up the cup, studies the colour, inhales the aroma. Then,
tentatively, takes a sip. It is a beautiful cup of tea. Perfect. He gives
a beatific smile. He nods slightly. The Man acknowledges his nod with a
satisfied, duty-done nod of his own.

Keith drinks the tea. He puts the cup down. Smiles.

He stands. Instantly two UNIFORMED MEN move in on both sides and pinion his
arms behind his back.

The folded handkerchief that the MAN whips out of his front pocket is a
HOOD.
And a door to the side of the table swings open. Revealing the Gallows.

FAST FADE TO BLACK.

SFX - Trapdoor crashes open.

MUSIC: I Like a Nice Cup of Tea - **TITLES**

First draft > **Second draft** > Final draft

EXT. STREET. DAY.

A suburb. A row of thirties semis.

INT. KITCHEN. HOUSE. DAY.

It's very nineteen fifties, cramped and rather shabby. Two children, **JAMES** aged 11 and **JACKIE** aged 9, sit at a square table which is covered with a chequered red and white plastic tablecloth. **CHRISTINE** stands by the sink washing up in a desultory fashion. She's in her mid thirties, attractive but slatternly. She doesn't look very happy.

Enter **KEITH UNDERWOOD**. He's early forties, harassed-looking and has a bad shaving cut on his chin plugged with bloodied tissue paper. He's obviously running late and he isn't very happy either.

Everyone ignores him. Keith goes to a work surface. There is a teapot under a tea cosy. He looks at a plate on the surface next to the sink. There is a bacon rind on it. He picks it up like he's a forensic scientist with a vital piece of evidence. He looks at Christine. She stares back, daring him to complain. He controls himself.

He picks up a packet of cornflakes from the table. Picks up a bowl. Tips up the packet. One cornflake falls out. IN SLOW MOTION.

Keith takes a deep breath. Finds a cup and saucer and his actions become almost ritualistic. He lifts the tea cosy, touches the pot, and yes - it's hot. He adjusts the cup and saucer, puts the strainer in place and slowly tips the pot. The tea is hopelessly weak, the colour of peat bog water. His face falls.

He takes the pot and, slowly and sadly, pours its contents into the sink.

Then he starts looking for the tea, opening cupboards. Christine stands back, arms folded. James and Jackie look faintly bored. Keith is about to crack and ask Christine where it is. But he sees the kitchen clock. It says twenty past eight.

Keith looks at his cheap-looking watch. It says five past eight. He taps it. It's stopped. This is very bad news.

Christine looks at her watch. It's much nicer than Keith's. Smiles.

EXT. HOUSE. STREET. DAY.

It's raining hard. As Keith hurries down the drive wheeling his rather tatty and rusty bike, he passes his neighbour **RICHARD**, who's about the same age but far more self assured; he's also tall, handsome and owns a car.

He's opening the driver's side door. He has an impressive-looking vacuum flask under his arm.

He grins as Keith rides off into the rain. Gets into the car.

EXT. SUBURBAN STREET. DAY.

It's no day to be cycling. Keith is wet and miserable. Passing car and lorries spray water all over him.

EXT. RAILWAY STATION. DAY.

We see Keith locking up his bike. He looks up at a station clock, hurries towards the entrance.

EXT. RAILWAY STATION. PLATFORM. DAY.

There's a small hatch behind which a **WOMAN** is serving drinks. Keith has one person in front of him. The tannoy crackles. It's echoey and largely incomprehensible.

The woman is pouring tea from a huge metal teapot. She serves the **MAN** at the head of the queue. He's very slow in finding change. Keith is almost dancing with frustration. A train pulls in. We hear the doors opening. The Man is still fumbling with his change. Finally he pays. Keith makes it to the counter.

The Woman tips the teapot. Keith turns briefly to see the commuters boarding the train. Come on. Come on. The teapot tips further and further - now the spout is pointing straight down. But it's empty. The Woman grimaces. Keith looks deeply frustrated. Behind him a whistle blows - he turns and runs for the train.

EXT. OFFICE BLOCK. DAY.

We see Keith hurry up the steps to the entrance.

INT. FOYER. OFFICE BUILDING. DAY.

It's four minutes past nine. The foyer possesses that quality of echoing emptiness that always makes the late arrival feel highly conspicuous. Two **RECEPTIONISTS** look at him with a mix of pity and interest, like watching a condemned man on his way to the gallows.

INT. OFFICE. DAY.

There are two rows of desks. All occupied, bar one. Keith enters, several people look up. His eyes flit to a glassed off inner office. He sees the door's shut. Looks relieved. Hurries across to the unoccupied desk. Sits, snatches papers from his in-tray.

 DISSOLVE TO LATER

The pile of papers in the in-tray has diminished. The pile in the out-tray has increased. The clock is ticking towards 10.45. Keith massages his temples, winces and then rubs sore eyes. He looks at the clock longingly. The minute hand touches the nine.

The door opens. A **TEA LADY** enters, pushing a tea trolley. A vision in white and silver. The light becomes warmer - as though the sun has just come out.

The tea lady, Denise, is also quite eye-catching. She's younger than you might expect, dark haired, pretty. Keith smiles at her. And at the large teapot. Keith's desk is nearest. She comes to him first.

He looks at her, smitten. She lifts the teapot. She pours the tea, picks up the milk jug. The cup is filled. She places it on a saucer and hands it to him. He stares at it, catches the aroma and is about to drink when...

The door of the inner office swings open. **HARRIS**, Keith's boss, stands in
the doorway. He's big, handsome, about forty. Alpha Male. He points a finger
at Keith. Beckons menacingly.

Keith hesitates for a second. Looking at the tea. Harris shakes his head.
Defeated, Keith puts his cup on the desk.

INT. INNER OFFICE. DAY.

We are looking down from a high corner. Keith sits huddled in on himself,
like prey, as Harris circles, drinking a cup of tea.

Keith's headache is now thudding on the soundtrack. We hear the slurping as
Harris drinks his tea. He picks up a sheaf of papers, stapled together, with
his free hand.

He drinks more tea. Keith's eyes follow every movement, longingly.
Keith raises his head a fraction, fingers to his temples. A distant rhythmic
thud is heard. Keith has a headache. A bad one.

Harris slams the paper on the desk in front of Keith, takes out a pen and
writes three words: **MUST DO BETTER**, large and bold. As he does so, Keith
can smell the tea, can see it only a few inches from his mouth – but it is
utterly unobtainable.

 CUT TO:

Keith is putting on his overcoat. A COLLEAGUE looks at him and at the cup
of tea on his desk. Harris is watching. A little pantomime is performed. The
Colleague gestures at the tea, raises his eyebrows in enquiry. Slowly and
with infinite sadness, Keith shakes his head. The Colleague takes the tea.
Sips. It's a good brew.

INT. CLOSE UP. DAY.

Keith is seated on a vile greenish-yellow sofa, it's scuffed and filthy.
Keith looks very hot. He is sweating, almost panting. An elderly woman
is complaining, pointing at papers on her lap and gesticulating.

The room is small and cramped. The **ELDERLY WOMAN** is in her early seventies
and none too hygienic-looking. We note a chamber pot tucked under the chair
she sits in. We see a fire, blazing. And we see the CATS. There almost too
many to count. They cover every spare surface. And they're malevolent-
looking cats that plainly add to the smell

Keith is sickened by the sight of a cat openly urinating in a corner.
It isn't discreet. You can **hear it**.

The Elderly Woman follows Keith's horrified, open-mouthed gaze. It doesn't
faze her over-much. She shakes her head indulgently, gets up and shuffles
out of the room.

 CUT TO

The Elderly Woman is passing him a cup. But it's from a tray with a filthy-
looking and chipped teapot, a half-empty milk bottle and a sugar bowl full
of tea-stained clumps of sugar. As for the cup he's being handed...

It may be china, but it's very hard to tell; the rim is too furry, plastered
with cat hairs. He tentatively wipes part of the rim, hairs mat
on his fingertip. No. He can't. He blows on it to gain time.

She smiles encouragingly. Keith gives a sickly smile. But he's saved by another cat, a large black beast which has learnt by example. It urinates loudly in a corner. The Elderly Woman turns to look.

Keith seizes his chance. He tips the tea into a plant pot.
EXT. OFFICE BLOCK. DAY.

The main entrance. Keith hurries in.

INT. OFFICE BLOCK. FOYER. DAY.

The big clock reads three minutes to two. The lift doors are open as Keith hares across the foyer to the lift. The doors shut just as he reaches them. He runs for the stairs.

INT. OFFICE BLOCK. FOYER. SIXTH FLOOR. DAY.

It is open and empty. There are two flights of stairs on either side of the lift shaft. Keith stumbles up the left hand one, gasping for breath. The clock on the wall above twin-sets of double doors reads one minute to two. He staggers across the foyer and virtually throws himself through the left hand doors into:

INT. CANTEEN. OFFICE BLOCK. DAY.

It's large and virtually deserted. About half a dozen late diners are just finishing up. The canteen is a 'collect your tray and move along' arrangement. The serving area occupies an entire wall of the canteen, with the kitchens behind. There are rails in front of it to corral the customers.

Keith pays no attention to the **KITCHEN HANDS** who are emptying and scraping the trays that contained the food. His glance goes straight to the area by the till. The hot drinks area. He dashes for the start of the rails and virtually runs along as the shutters come down in an almost synchronised fashion.

Each one shuts just as he reaches that section of the serving area. Despairingly, he watches as a **WOMAN** reaches for the shutter that will keep Keith from his goal...

But too late. The shutter comes down. Enraged, Keith hammers on it. No response. Keith raises his fist to hammer again, but thinks better of it. His shoulders slump. He walks away.

INT. OFFICE. DAY.

Keith is working. He has a headache. A very bad headache. Everything seems extra noisy. He stops to hold his head in his hands. He tips up his aspirin bottle; an aspirin falls out. He puts it in his mouth and swallows it. It's not easy swallowing a dry aspirin and the strain shows.

He looks up at the clock. It's a couple of minutes to three. He resumes work.

We go in close on the clock. And see the big hand touch the twelve.

Keith puts his pen down, checks his watch. The door opens. Denise enters. Keith lets out a sigh of relief. He smiles at her. She smiles back. He's about to say something when the door of Harris's office opens. Harris steps out. Beckons to her.

Denise smiles apologetically at Keith. She pours a tea and takes it into Harris's office. The door closes. There is a general frisson of disquiet round the office – but no-one quite knows what to say.

It is as though time has frozen.

DISSOLVE TO:

The clock is now at ten past. There is a definite restlessness in the
office. Keith's headache is plainly now excruciating. Suddenly he decides
he must do something. He stands up, pushes his chair back. Walks towards
Harris's office. Raises his hand to knock, thinks better of it. Then courage
returns. He raps on the door. There's no answer.

He looks at the tea trolley. Raises his hand to knock again. Instead he
grasps the handle and walks straight into:

INT. HARRIS' OFFICE. DAY.

There is a cup of tea on the desk. But this is not the first thing Keith
notices. Or us. Technically speaking, Denise and Harris aren't actually
having sex, but they're as close as makes no difference. Keith is appalled.

They spring apart. Denise gasps and starts trying to make herself decent.
Harris looks embarrassed but angry.

But Keith is angry too. He picks up the cup of tea and flings the contents
all over Harris.

INT. FOYER. OFFICE BLOCK. DAY.

Keith is being escorted from the building by two uniformed **COMMISSIONAIRES**.
He is clutching his briefcase and, in the other hand, a brown envelope
and various bits of paper.

As he passes the reception desk, the RECEPTIONISTS look at him with vague
sympathy. They are both drinking tea.

EXT. STREET. CITY. DAY.

Keith is walking along looking somewhat dazed. He passes a very expensive-
looking café with a snooty looking **MAÎTRE D'** at the door. In the road, a
gang of **WORKMEN** are using a pneumatic drill. It yammers into life. Keith
winces. His headache is still bad. Then he looks at the café. He opens his
brown envelope. There's quite a lot of cash inside. He turns back.

EXT. CAFÉ ENTRANCE. DAY.

He passes the Maître d' and, airily, flips him a coin.

INT. CAFÉ. DAY.

It's very classy. Keith is seated towards the rear. We can still just hear
the occasional staccato bursts from the pneumatic drill but that's not
bothering Keith over-much. He's concentrating on the little tea ceremony
that is being performed in front of him. A very neatly uniformed **WAITRESS**
is about to pour him tea.

This is a truly impressive tea service; the business. The cup is placed on a
saucer in front of Keith. The Waitress lifts the teapot. The pneumatic drill
stutters and there is a very loud **BANG.**

This is followed by a flash of blue light. All the lights go out.
The Waitress screams, tips the teapot – over Keith's crotch.

EXT. STREET. CITY. DAY.

It's still raining. Keith hurries along the street. And turns into the
entrance of a RAILWAY STATION.

INT. STATION BUFFET. DAY.

It's busy, but there are a couple of tables free. The place is self service.
He takes a tray and slides it along the counter until he reaches the point
at which hot drinks are served. A bored-looking girl of about eighteen
stands there. Eventually she notices Keith.

She picks up a pot, picks up a stainless steel infuser on a chain and puts
it in the pot. The she manoeuvres the pot under the spout that spits out
boiling water.

The Girl blasts boiling water into the pot. Puts the pot, a cup and saucer,
a bowl of sugar and a small jug of milk on the tray.

DISSOLVE TO:

Keith is sitting at a table. He's waiting for the tea to brew. He touches
the pot. Looks at his watch. He rubs his hands in anticipation.

Looks at his watch. Drums his fingers. Then notices a sudden in-rush of
customers. Looks at his watch again.

He picks up the pot and pours the tea. It's a rich golden brown. Keith's
nostrils twitch. It's perfect. He relaxes. At last. He picks up the milk
jug. Pours the milk, a pure stream of white. Only it's not. It curdles.

He looks at it with disbelief. Then anger. He picks the tray up and heads
towards the counter. But it's now very busy.

He tries to attract the girl's attention but there's a press of customers
at the counter. She ignores him.

He puts the tray down on a trolley. And dejected but hurried, heads out
onto the platform.

INT. BUFFET CAR. TRAIN. DAY.

It's busy, but not too crowded. There are about eight or nine customers.
Keith is second in the queue. There is a **FAT MAN**, a business type, in front
of him, taking a cup of tea from the **STEWARD.**

He lifts up the teapot to pour a tea for Keith it. But...

The Fat Man cries out in pain and alarm, drops his tea, clutches his chest
and pitches forward. Everyone is stunned, but the Steward recovers fast.
He pushes open the half doorway and steps out.

Immediately everyone is focused on the Steward as he starts to try to help.
Everyone except Keith. He's had enough.

He steps behind the counter and pours himself a tea. In a mug. It looks
good. He lifts it to his lips just as one of the group around the stricken
fatty turns round and, on a nod from the Steward, pulls the communication
cord. The train brakes sharply.

The mug flies from Keith's hand. The teapot crashes to the floor.

EXT. HOUSE. STREET. DAY.

Keith walks back to his front door. He looks almost broken. A car is heard
passing; he winces. His headache is killing him.

He opens the front door.
INT. KITCHEN. DAY.

Keith is writing a note. It reads:
'Home early. Gone upstairs for a lie down with a nice cup of tea.'

He then shakes a couple of aspirin out of a bottle, puts them in his mouth,
washes them down with a glass of water.

He picks up a cup of tea.

INT. BEDROOM. DAY.

Keith enters. Christine is in bed with Richard. They both sit up gobsmacked.
Keith is utterly stunned.

He drops the teacup; we follow its fall in slo-mo. As it hits and splashes,
we go straight to a violent flash of white light.

ON WHITE

INT. A ROOM. DAY.

It's white and details resolve out of it. A snow-white tablecloth. A silver
tray with tea things laid on it. A white teapot, a white milk jug, a
beautiful and capacious white china cup on a white saucer. The scene has
a slightly surreal burnish to it.

A MAN, grave and dignified, looking like a high-grade butler and wearing
white gloves picks up the teapot and pours. A golden stream of tea arcs into
the cup. Then he pours the milk and passes the cup to Keith. Keith is framed
against a white background.

> BUTLER
> There you go, Mr. Underwood,
> a nice cup of tea.

Keith picks up the cup, studies the colour, inhales the aroma. Then,
tentatively, takes a sip. It is a beautiful cup of tea. Perfect. He gives
a beatific smile. He nods slightly. The Man acknowledges his nod with a
satisfied, duty-done nod of his own.

Keith drinks the tea. He puts the cup down. Smiles.

He stands. Instantly, two **UNIFORMED MEN** move in on both sides and pinion
his arms behind his back.

The folded handkerchief that the MAN whips out of his front pocket is a
HOOD.

And a door to the side of the table swings open. Revealing the **GALLOWS.**

FAST FADE TO BLACK.

SFX – Trapdoor crashes open
MUSIC: I Like a Nice Cup of Tea

TITLES

Picture credits

02-03 *A Chump at Oxford*. HAL ROACH/UA/The Kobal Collection

14 *Barton Fink*. Circle Films/The Kobal Collection

17 *The Purple Rose of Cairo*. Orion/The Kobal Collection

18-19 *Thelma and Louise*. MGM/Pathe/The Kobal Collection

25 *Floored*. Alisha McMahon/York St John University

28 *Psycho*. Paramount/The Kobal Collection

31 *Dead of Night*. Rank/The Kobal Collection

33 *Memento*. Summit Entertainment/The Kobal Collection

36-37 *Jaws*. Universal/The Kobal Collection

41 *Flapwing and the Last Work of Ezekiel Crumb*. Alasdair Beckett-King/Kettle Black Films/York St John University

Floored. Alisha McMahon

47 *Cupid of Ovid*. Danny Brierly/York St John University

48-49 *Brazil*. Universal/Embassy/The Kobal Collection

51 *Star Trek*. Paramount Television/The Kobal Collection

55 *Stalled Juncture*. Mark Preston/York St John University

62-63 *The Spy Who Loved Me*. Danjaq/EON/UA/The Kobal Collection

69 *Sexy Beast*. Channel 4/Kanzaman/The Kobal Collection/Nick Wall

73 *Se7en*. New Line/The Kobal Collection/Peter Sorel

80 *Groundhog Day*. Columbia/The Kobal Collection

82 *The Goat*. The Kobal Collection

88-89 *The Apartment*. United Artists/The Kobal Collection

O ford & Cherwell Valley College
Learning Resources

With thanks for their contribution:

Alasdair Beckett-King
Danny Brierly
Thomas Gladstone
Alexander Johnson
Alisha McMahon
Mark Preston
Miles Watts
Alex Woodcock

Kettle Black Films
Hum-Drum Films

Special mention goes to the staff and students of Film and Television Production at York St. John University. It just might be the best degree programme in the world. Particularly Andrew Platts and Dr Jeff Craine for their support.

Inspiration to start came from Prof. Neil Sinyard and Dr Andrew M Butler. You write loads of stuff.

Thanks go to AVA Publishing, particularly Colette Meacher and Lucy Tipton for their expertise and especially their patience.

Jimmy, John and Rob want to thank their respective families and, indeed, each others' families for their support during the writing process. Without you, etc.

The authors would like to thank each other in turn – one after the other, with a cheery smile and a hearty handshake and perhaps a manly slap on the shoulder.

Special thanks to:

Jennifer, Fred, Stewart, Hilary, Roger, Kat, Meredith and Agatha, without whom this tome would never have been edited.

Very special thanks to:

Mark Herman

This book is dedicated to Mr Pickles and Mr Truffles who are always an inspiration.